GARDENS IN
Watercolour

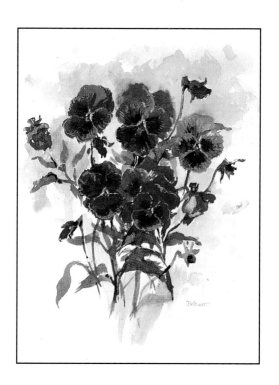

GARDENS IN WATERCOLOUR

WENDY JELBERT

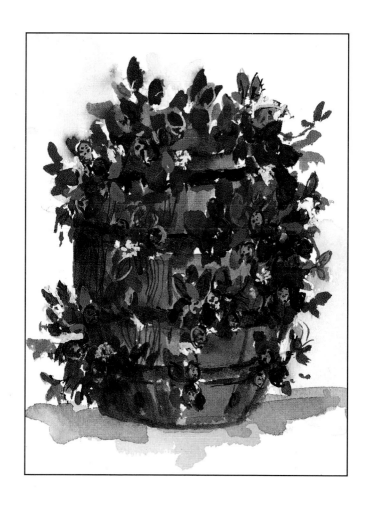

B.T. Batsford Ltd, London

Acknowledgement

Many thanks to Margaret Plant for all her
help as a friend and student.

First published 1992

Typeset by J&L Composition Ltd, Filey,
North Yorkshire

and printed in Singapore

Published by
B.T. Batsford Ltd
4 Fitzhardinge Street
London W1H 0AH

A catalogue record for this book is available
from the British Library

ISBN 0 7134 6569 7

CONTENTS

INTRODUCTION

What artist can resist the magnetism of a garden? Whether it be large or small, neglected or formal, window-box or balcony, we can find joy at every turn. Each and every garden is unique. They differ in growth, content, style and design, and each provides a vivid insight into the character of its creator. Like a much-loved sketchbook, a garden can offer an inexhaustible source of ideas to inspire the watercolour painter.

Gardening is not a modern phenomenon: Egyptian frescoes at Thebes depict gardens lush with vines, palms and fishponds, and Persian miniatures depict beautifully symmetrical gardens adorned with fruit trees. Travel, wars, fashion and economic circumstances all encouraged the spread of indigenous plants and crops to every corner of the world. In Britain, for instance, the Romans introduced salad crops, beans and cabbage.

With the formation of the Royal Horticultural Society in 1804, gardening began to grow in popularity in Britain, and the idea of providing extra food for large families or adornment in the house caught people's imagination. Books on gardening, in particular those of Gertrude Jekyll, had great influence on a rapidly changing scene. The larger estates were disappearing and at the same time an improvement in the general standard of living led to the development of the neat, smaller home with its own garden. Miss Jekyll's herbaceous border became a realistic possibility for a growing number of people. Two World Wars followed, owner-occupation of homes increased, allotments flourished and flowers were grown as well as food; gardens were planned, arranged and cosseted.

In this book, I intend to describe the many tips, secrets and techniques that I, as a professional painter and teacher, have learned over the years. We will explore composition, how to render the fascinating illusion of textures, and how and when to include figures and animals within the garden setting. The step-by-step projects will help you gain confidence as well as teach you to exercise your own imagination.

The artist in his or her garden has many advantages over the landscape or seascape painter. We have shelter and home comforts close at hand, and we are spared the tiresome task of selecting and packing every item that may be needed for an outdoor expedition. If we feel like working quietly without the interruption of onlookers, we can do so.

Happily, enjoyment of this book is not limited to those fortunate enough to have their own garden. In my experience, everyone who has a garden is delighted when someone finds it interesting or charming enough to inspire a painting. The gardens of friends and neighbours should provide a rich source of ideas. An added bonus is the growing number of beautiful parks and gardens now open to the public. All the would-be garden painter has to do is to stop and look.

LEARN TO LOOK

Whatever the time of year, the garden painter need never be at a loss. Every season brings its own reward, with changing colours, growth and patterns, and the distinctive variations and characteristics that each month reveals. Within the most ordinary gardens, nestling in the nooks and crannies or secret corners lie a myriad of subjects waiting to be found.

In the past I seemed to search endlessly for the perfectly presented scene to paint, but I rarely found one conveniently packaged! There was always the need to study, interpret or adapt the chosen scene. Looking, just looking, takes time and effort. Discovering and developing ideas about a subject takes imagination and vision, only achieved as the result of hard work and experience. You will benefit from studying other people's work at art galleries and exhibitions. Your own vision will be enriched by looking at the world through their eyes. You should then allow yourself to interpret their ideas in your own way, mentally, or in your sketchbook. This will help you to notice and appreciate potential ideas wherever you go.

When you are planning a painting, you can save yourself much disappointment by the use of a simple viewfinder. You can easily make your own by cutting a rectangular hole in a postcard, or you can buy one with an acetate window marked with a grid. This will help you to select the most pleasing and poignant composition, and also to transfer the scene correctly to your paper or canvas.

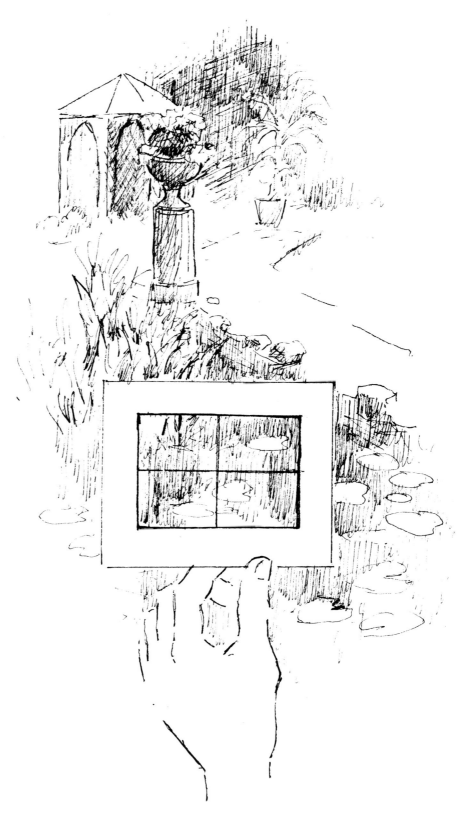

Figure 1. *A viewfinder will help you select the most pleasing composition.*

Here is an example from my own sketchbooks. My sketchbook is 30 cm × 25 cm (12 in × 10 in), hardback, with a protective plastic cover. I use a retractable-blade knife to keep my graphite pencils pointed. Nowadays my sketchbooks are crammed not with neat and perfect renderings but with interesting little jottings, colour notes, sketches of items, oddities, scraps from newspapers and magazines, photographs and tonal studies, all ripe for reference and information. Culling realistic ideas from the garden is essential, but abstract ideas and personal images deserve an airing too. Valuable work can be done in just a few moments. Always carry a pocket-sized sketchbook wherever you go and utilize any spare moment. Like me, you may then discover that when it is wintry outside you have enough information and ideas within your studio to keep you happy and busy!

Figure 2. *A study from my sketchbook.*

MATERIALS AND TECHNIQUES

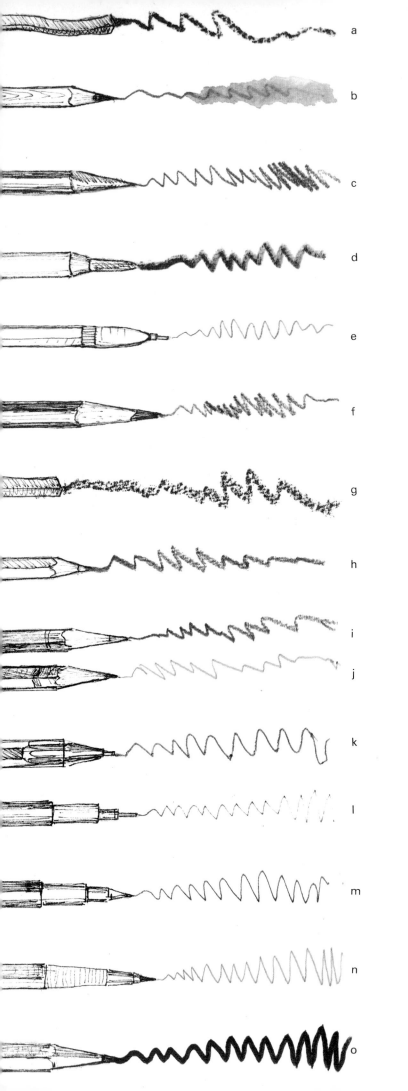

a

b

c

d

e

f

g

h

i

j

k

l

m

n

o

MATERIALS AND TECHNIQUES

DRAWING MATERIALS

There is an incredible range of drawing instruments in every colour and medium. I have listed many of them here, but it is not necessary to rush out and buy them all. You will, however, need to have a good selection of graphite pencils. These range from the extremely soft 9B to the very hard 9H. Try scribbling and shading with as many as possible in order to see their various qualities and possibilities (see opposite):

(a) stick of willow charcoal (this can be bought individually)
(b) aquarelle lead pencil (used as an ordinary pencil, or used wet to imitate watercolour)
(c) graphite pencil with a plastic coating

Figure 3. *A variety of marks made with different drawing instruments. Experiment with as many as possible to see which you prefer.*

(d) watercolour brush, resembling a very long, soft felt-tip pen
(e) pop-up disposable pencil, with a small rubber and spare leads
(f) charcoal pencil (a clean form of charcoal stick)
(g) Conté pastels (a hard square pastel available in lovely muted shades)
(h) aquarelle coloured pencils (again, these can be used dry or wetted)
(i–j) lead pencils, ranging from 9B to 2H
(k) fine felt-tip for thin, bold lines
(l) hi-tech fine-point, steel-nibbed pens for delicate work
(m) steel-nibbed drawing pen for fine sketching
(n) propelling pencil
(o) wide felt-tip for strong statements

The use of a fixative will preserve your drawings and is advisable for fragile charcoal and pencil work. I use an odourless and ozone-friendly spray which is now available.

EXERCISES

Starting with a blank piece of paper or canvas can be rather daunting, even for a more experienced artist. Like a dancer or musician, you might like to loosen up with a few exercises before you start work on this white expanse. Try quickly drawing a series of ovals, circles and lines for a moment or two, using the whole arm, not just the fingers, and varying the pressure.

An improving drawing technique will soon demand use of more than just line. I have devised eight basic exercises which you can see overleaf (Figure 4). These exercises introduce textures and patterns. The examples might suggest a number of things such as woodgrain, bark, grasses, walls and running water. While you are practising these, also try out ideas of your own, aiming to improve your artistic vocabulary.

(a) Charcoal drawing in short, curved strokes, varying the pressure. Try smudging for different effects.

(b) Graphite pencil. Try variations of cross-hatching and open lines, altering the angles and pressures.

(c) Using a fine steel-tipped pen, experiment with circles, dots and hatching.

(d) Draw different-sized rectangles. Vary the size, tone and method.

(e) Using a pen and permanent ink, draw fine lines with dashes and cross-hatching.

(f) Use charcoal pencil to achieve a woodgrain effect, with trailing lines and dashes.

(g) Using a graphite aquarelle pencil, zigzag and scribble vertical strokes, then partly cover them with a wash of water.

(h) Use a very soft pencil (8B), curving the strokes to create a busy, interesting result.

PAPER

There are papers of every description on sale today and they come in all colours, weights and surface textures. Since your choice of paper can greatly influence the final work, it is important to be familiar with them all. For fine or detailed work, a smooth or slightly textured paper is advisable and a good-quality cartridge paper is suitable for most pencil and ink work. Using a heavier paper for aquarelle pencils, gouache or watercolours will reduce the risk of a 'cockled' painting. For large, bolder paintings, I normally use a 90 lb (190 gsm) or 140 lb (300 gsm) paper with a roughened surface.

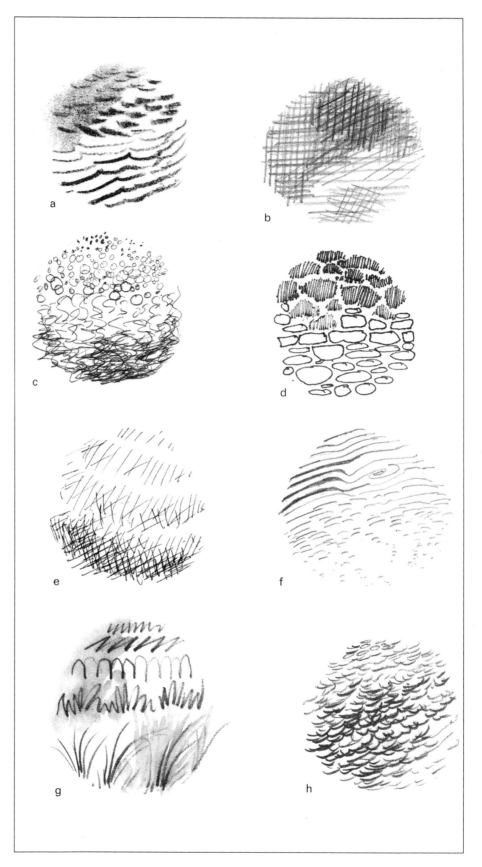

Figure 4. *Exercises introducing texture and pattern.*

WATERCOLOUR MATERIALS

The wide tonal range of watercolour can be exploited either alone or in conjunction with other compatible media (right):

(a) Watercolour — this transparent medium comes in pans or tubes, and in artist or student quality.
(b) Gouache — this is also available in tubes or pans. More opaque and flat than traditional watercolours, it allows you to cover a dark tone with a lighter one. Gouache can give depth and solidity to a painting.
(c) Bottled artists' colour — this is quite a recent product. It is a transparent, high-colour medium and can be considered a cross between ink and watercolour. It comes in pots with a suction dropper in the lid.

TOOLS

(d) drawing or ruling pens, invaluable for the application of masking fluid (the space between the two points can be adjusted to control the width of line required)
(e) round-headed sable brushes, ranging in size from 000 to 14
(f) flat-headed brushes, available in bristle or sable, and ideal for large areas
(g) fan brushes, made from sable or nylon, excellent for merging edges and for foliage patterns
(h) rigger brushes, ranging in size from 0 to 6, invaluable for detailed work such as tapering branches

Figure 5. *A selection of paints and tools.*

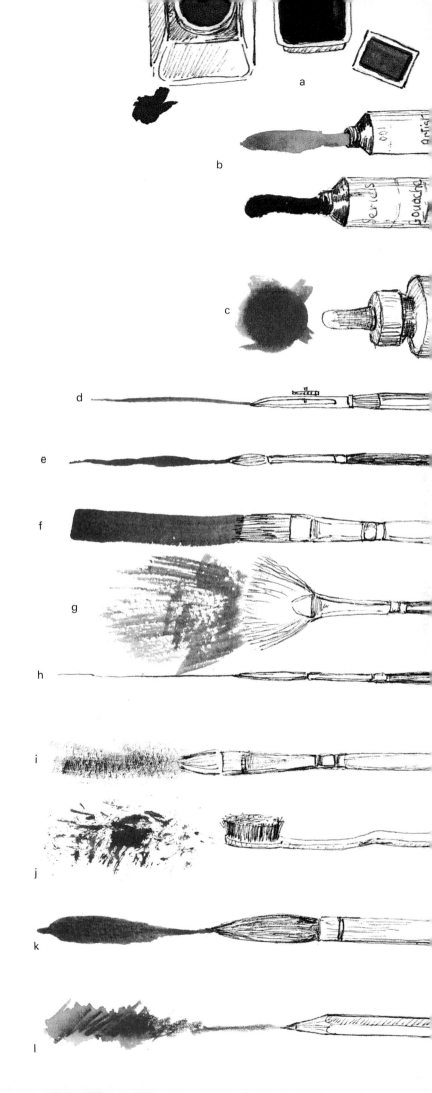

(i) hog-hair brushes, in sizes from 1 to 12, ideal for applying a 'scumble' (using one colour over another)

(j) old toothbrush for splattering masking fluid or paint

(k) Japanese brushes, with a generous amount of hair and pointed tips; very versatile, giving a beautiful multi-faceted painted line

(l) aquarelle pencils for detailed work

EXERCISE 1

It is important to experiment with colour when working on the exercises on this page. By doing this you will discover what an exciting and versatile medium watercolour is.

Materials

Watercolours, ox gall liquid, sharp knife, cottonwool buds, eau-de-cologne

Top left: wet the paper and let the watercolour flow gently.

Top right: watch two colours mingle together.

Second left: apply dry paint with a wide hog-hair brush, using brisk strokes.

Second right: drop ox gall into a watercolour wash and watch the 'spidery' effects materialize.

Third left: drop eau-de-cologne into watercolours and watch the result. See the effect of adding yet another colour.

Third right: when an area of watercolour has dried, scratch out shapes back to the bare paper.

Bottom left: apply a flat area of watercolours without making streaks.

Bottom right: while the watercolour is still wet, try to 'lift' patterns of light using a cottonwool bud.

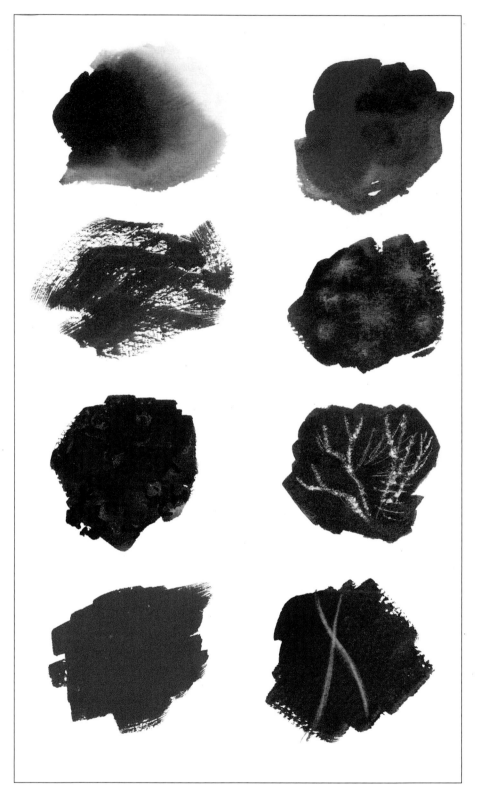

Figure 6. *Try these experiments using different colours and record the results for future use.*

EXERCISE 2

Materials

Old toothbrush, masking fluid, gouache, watercolours, aquarelle pencils, rock salt, bottled artists' colour, masking tape

Top left: dip the toothbrush into wet paint; hold it over the surface of the paper and gently run your fingers over the bristles to create a spray of paint.

Top right: draw masking fluid on dry paper with a ruling pen and leave to dry. Apply a wash and allow this to dry. Peel off the masking fluid with your thumb to expose the original paper.

Second left: paint an area of solid colour and allow to dry. Draw over the surface with coloured pencils.

Second right: try out the aquarelle pencils. Lay down three colours and partially cover them with water. Observe the reaction.

Third left: cut out shapes from masking tape and stick them to the paper. Wash over with bottled artists' colour and leave to dry. Pull off the tape to reveal the untouched paper beneath.

Third right: sketch a simple pattern using aquarelle pencils. Wash them together so that the colours start to mingle.

Bottom left: drop paint vertically onto a wetted surface to see how the colours merge.

Bottom right: drop some rock salt into a wetted circle of watercolour. When thoroughly dry, brush it off, leaving the surface mottled and roughened.

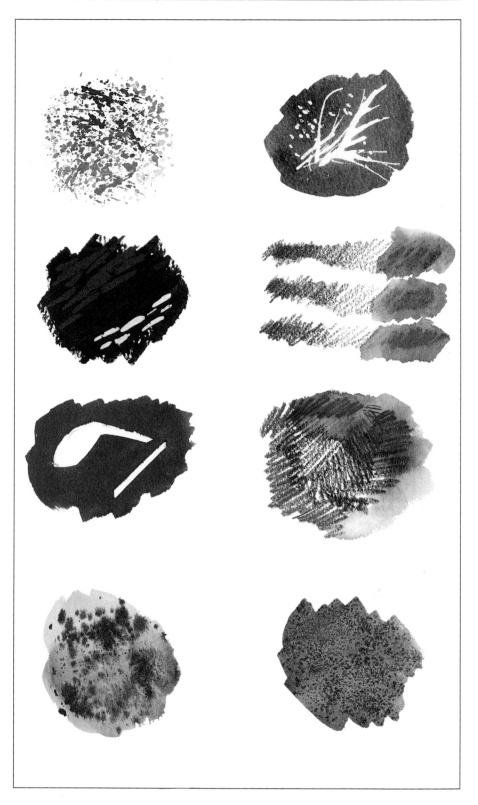

Figure 7. *Exercises exploring the use of washes and textures.*

EXERCISE 3

Materials

Oil pastels or candle wax, sponge, inks, aquarelle pencils, watercolours, gouache, cocktail stick

Top left: draw a pattern in oil pastels or candle wax and apply a watercolour wash over it. The waxed areas will repel the wash and remain free of paint.
Top right: dip a sponge into wet green watercolour or gouache and 'stipple' it onto your paper to create a 'foliage' effect. Try this out with thicker paints and other greens.
Second left: experiment with a collection of wet and dry aquarelle pencils on a watercolour background.
Second right: apply wet watercolour and immediately streak ink into it with a cocktail stick. Think about how you could use this effect.
Third left: discover the potential of various inks and washes, using different amounts of water and different brushes.
Third right: using ink washed together with watercolour, experiment with hatching and various ink marks within the watercolour wash.
Bottom left: drop and dribble inks into watercolour or gouache washes.
Bottom right: using aquarelle pencils, inks and watercolours, try out various effects, adding and merging them into each other.

There really is nothing new in the techniques used by artists — nearly everything has been done before. Turner added soap to some of his paintings to give depth and vitality, and he often

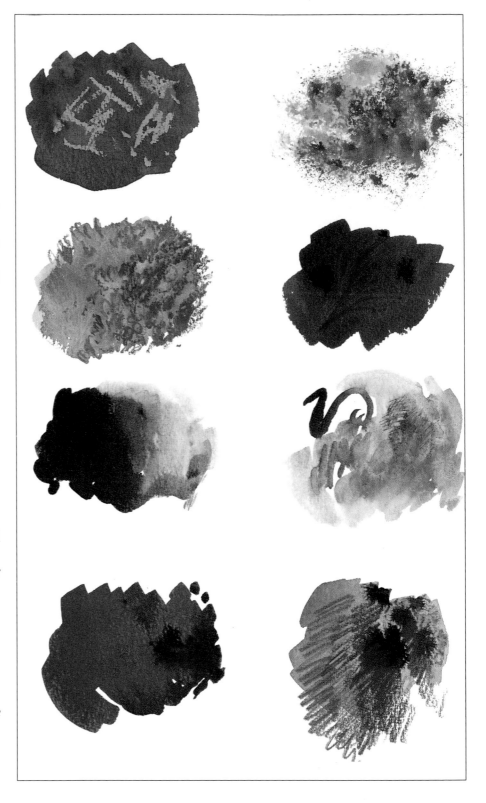

Figure 8. *Familiarize yourself with the potential of different painting materials.*

used the stippling effect. De Witt and Girtin added fresh colour to first washes of 'wet-into-wet' to give variety and spontaneity. David Cox used separate strokes, more often used by oil painters.

If you study the work of past and present painters, you may recognize many of the methods and techniques mentioned in this chapter. Artists constantly strive to express their ideas in an original way; there is no 'right' or 'wrong' way in drawing or painting. If the result is appropriate or pleasing, anything goes!

Figure 9. *Combining several media to paint a single subject is a valuable learning process.*

MULTI-MEDIA SUBJECT

The dewy, delicious shades of orange, red, ochre and green made this basket of produce, fresh from my garden, an ideal subject for a still life (below). It is interesting to note the results I have achieved by using a variety of different media.

Materials

Watercolours, bottled artists' colour, gouache (red, green and yellow), aquarelle pencils (yellow, green and violet), masking fluid

(a) Gouache: apply an initial wash of red. When dry, paint over with yellow, allowing some of the first colour to 'gleem' through. Quickly apply light green to the top layer, with a touch of white for the highlight.
(b) Aquarelle pencils: draw in the fruit with one of the pencils, using strong strokes to define the apple's fullness. Apply red and violet to the shaded side, changing to yellow towards the top. The indentation is shaded in red and I have drawn on a deep violet stalk. Light green was then placed in strong, open lines, which fade into the yellow that shows through earlier layers.
(c) Bottled artists' colour: apply masking fluid to the highlight and allow to dry. A diluted yellow wash with a dash of green is applied as the first layer. While still wet, subtle patches of red and orange are applied to the farthest sides of the apple. When drier, paint a final wash of red, allowing the other washes to show through.

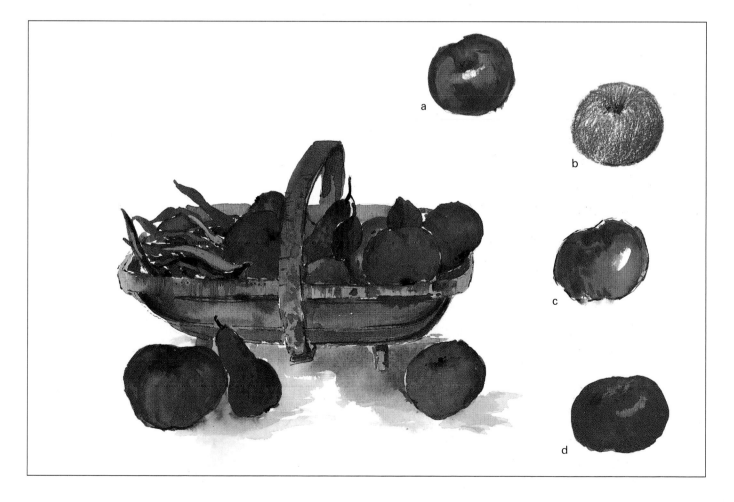

Use a broken outline of ink to prevent any unnatural hard edges.

(d) Gouache and watercolour: first apply a wash of solid green gouache to the apple. When dry, paint a loose wash of bright red and yellow watercolour. Lift out the gentle highlight with a dry brush.

(e) Watercolours: this medium is very transparent and you need to work from light to dark. Lay down a yellow-green wash to give a 'glow' through future layers. When dry, add orange and a final darker red painted into the right-hand side 'wet-into-wet'. A splash of green can be dotted into this, creating a more natural tang of colour.

Compare all these finished effects, and try another subject, such as a pear.

ANATOMY OF PLANTS, FLOWERS AND TREES

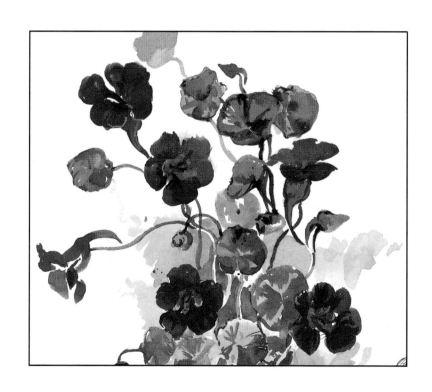

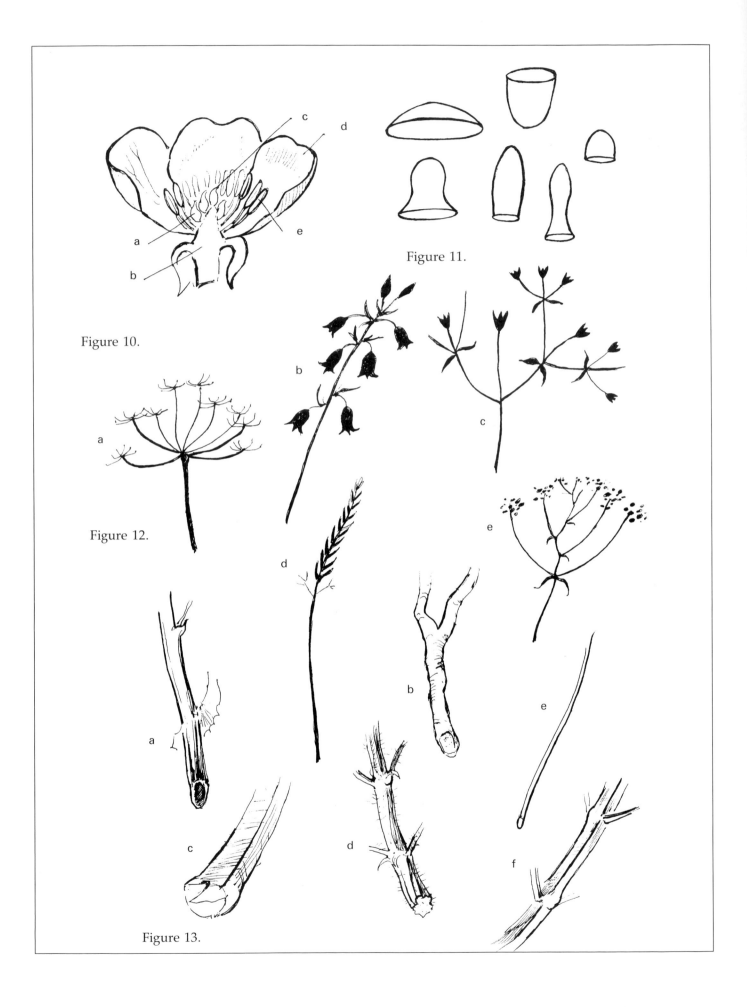

Figure 10.

Figure 11.

Figure 12.

Figure 13.

ANATOMY OF PLANTS, FLOWERS AND TREES

Inevitably, the garden painter will at some time wonder why flowers and plants are so captivating and alluring. An insight into their basic structure is essential to reveal the answer. As Leonardo da Vinci showed, it is important for the painter to fully understand his subject, both from an aesthetic and botanical point of view.

Never before has there been such a variety of garden plants for us to paint, including exotic species from overseas and new hybrids as well as the simple wildflowers that have strayed from woods and fields. Beneath the proliferation of colour, shape and growth pattern lies the plants' basic structure. If you understand this, your work will have authenticity, regardless of whether you choose to paint in a loose, free manner or an illustrative, literal way.

Figures 10–13. Building up a record of basic flower forms is a useful source of reference.

Most flowers and leaves are seasonal, so it pays to have as many references as possible. A simple filing system of drawings, magazine cuttings, photographs and seed packets will prove invaluable. I have found many useful books very cheaply at car-boot sales, second-hand book shops and jumble sales. Some children's books are excellent too!

FLOWER FORMS

Figure 10 shows a vertical section through a dog rose. Examination of these delicate parts will help you to create flowers correctly: (a) pistils (b) receptacle (c) stigma (d) stamens (e) sepals.

Figure 11 shows the basic shapes to which most flowers conform. More complicated flowers may combine two or more of these shapes.

Figure 12 shows flower silhouettes. In these simple diagrams I have illustrated some examples of these more complicated flower forms:
(a) umbel, as in cow parsley
(b) raceme, as in bluebell shapes
(c) forked cyme, as in the herb Gallant Soldier
(d) spike, as in grasses
(e) corymb, as in the tansy family

STEMS

These are often more complex than they appear at first glance because of their varied textures, colour and construction (Figure 13):
(a) thistles have hollow and ridged stems
(b) geraniums have solid and rounded stems
(c) rhubarb has a pink, fleshy, firm stem
(d) stinging nettles have round hollow stems with hairs
(e) some grasses have a hollow, reed-like appearance
(f) dead-nettle weeds have square, solid stems

PETALS

The colour, shape and scent of flowers, fruit and vegetables attract insects, which pollinate them. The most conspicuous feature of any flower is usually its petals.

In Figure 14 (right) I have painted a selection of petals from my garden — buttercups, nasturtiums, roses, carnations, pansies, bluebells and daffodils. Isolating them emphasizes the differences between their trumpets, frills, bells, ovals and star shapes, plus, of course, their gorgeous colours. I used a mixture of watercolours and gouache on a 140 lb (300 gsm) paper.

LEAVES

Plants have many systems of leaf arrangement and it is important to appreciate this in order to portray them correctly. Notice, in particular, the way the leaves join the main stem (Figure 15, opposite):

(a) single leaves growing directly from the stem of a tulip

(b) leaves may also be arranged in groups up the stem, as in the case of this vetch

(c–d) these rose leaves are paired and grow at right-angles from the stem

(e) a more complex growth pattern, in which leaves appear to grow from the stem in a spiral

(f) ivy leaves grow in a staggered manner

(g) iris leaves are wrapped around the stem

(h) the whorled leaf formation of the pink family

Draw a leaf from different angles as in Figure 16 (opposite, below), observing the central

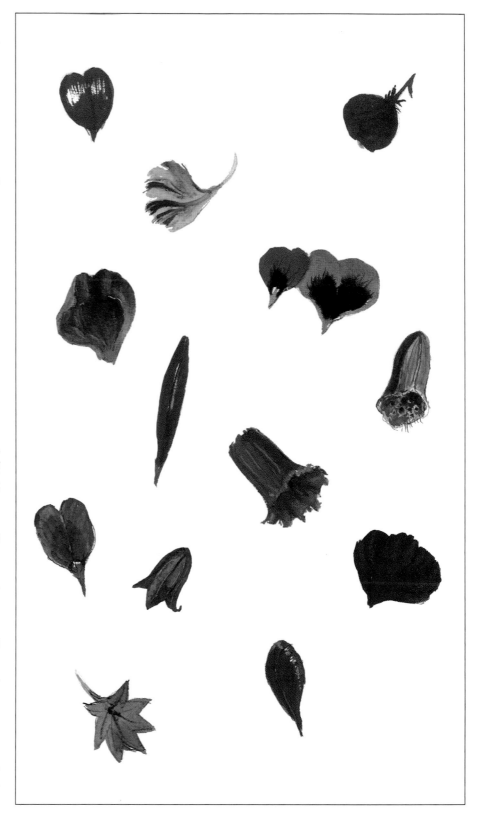

Figure 14 (above). *A selection of petals, the most colourful part of the flower.*

Figure 15. *The ways in which leaves are joined to a stem differ widely.*
Figure 16. *Drawing leaves from different perspectives.*

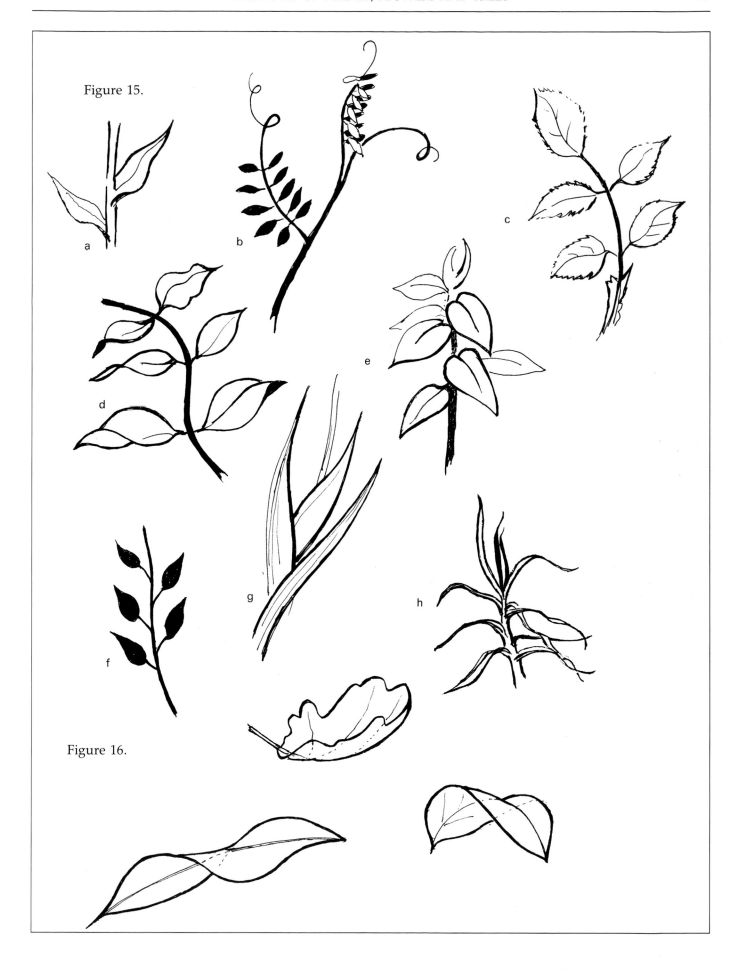

Figure 15.

Figure 16.

curve. Keep the leaf on course
by drawing it as though it were
transparent and rubbing out the
guidelines afterwards.

Gouache is especially suitable
for leaves with pronounced
markings (right). Amongst these
examples are the leaves of the
passion flower, buddleia, laurel,
chrysanthemum and hydrangea.
I use viridian, sap green, yellow
ochre and cadmium yellow,
increasing the proportion of
yellow for the brighter, warmer
sections. A touch of violet and
olive green is used for the darker
areas.

My study of sunny-faced
nasturtiums (opposite), with
their beautiful necklaces of disc-
shaped leaves, was produced
from the pen and pencil
drawings in my sketchbook,
completed many months before.

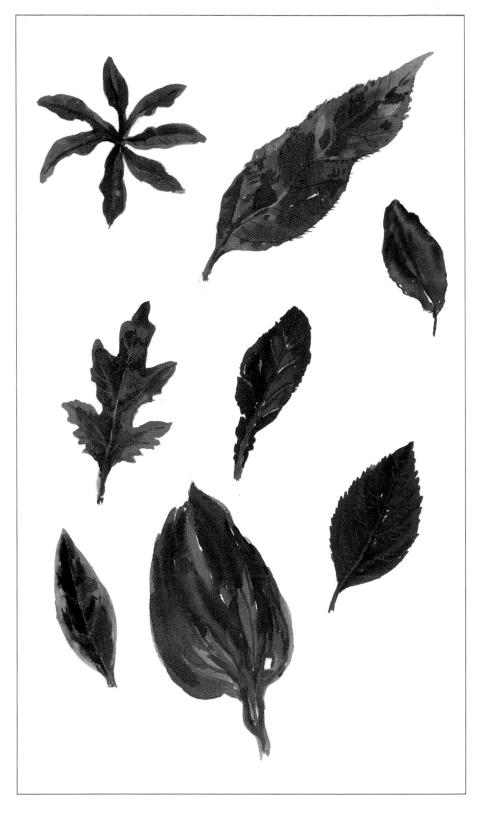

Figure 17 (above). *Gouache can be used to paint in leaf markings.*

Figure 18. *A study of nasturtiums completed with the aid of sketchbook references.*

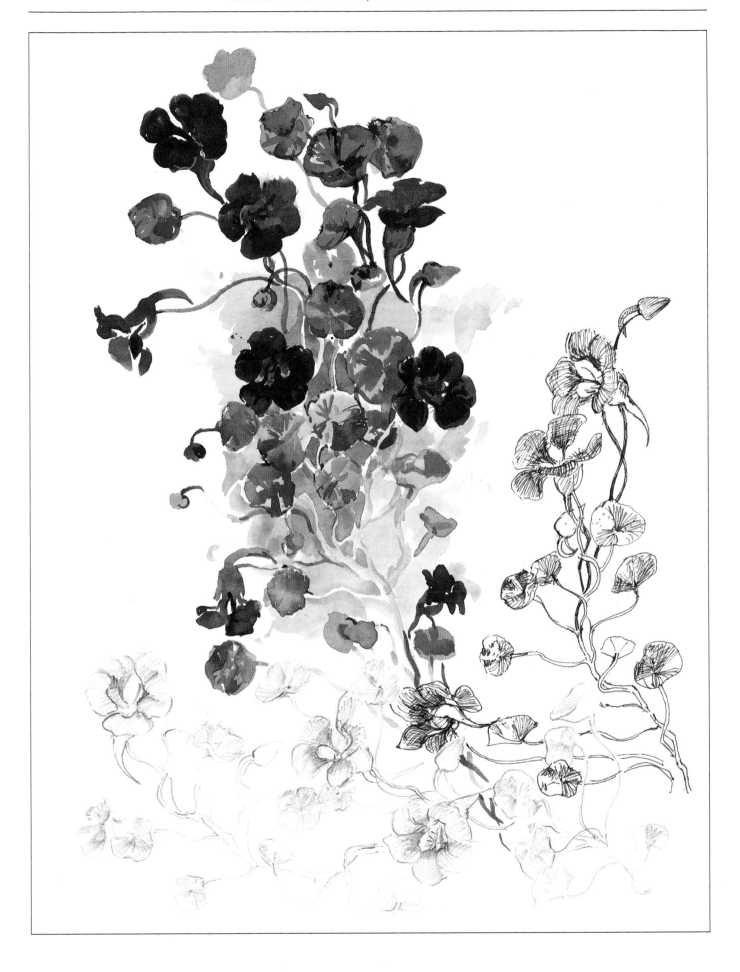

TREES

Not everyone's garden will be the natural host to a stately tree, so some cheating may be required here! The tree is the king of all plants, and the presence of trees in your garden paintings can often provide you with some unique opportunities. Strong, tall, providing vertical interest, a screen or backcloth for shady places and mysterious nooks, trees can provide a natural frame for the focal point in your painting.

The essential character of a tree is set by its countless leaves and the way in which they burst, star-like, from a delicate tracery of branches, stems and twigs. The whole is so massed together that we can also think of them as one well-defined shape, not just as the sum of its elements. We would not wish to attempt to paint every leaf on a tree but, like flowers and plants, it is essential to study and identify the different varieties, shapes and structures in order that our paintings are convincing. Do not forget that trees grow from the ground and, in many cases, hint at the huge substructure of roots below the earth. To illustrate how much they all vary, I have sketched six common tree silhouettes (below).

HAWTHORN

The study opposite, both in leaf and bare-branched, was for me a most enjoyable and worthwhile exercise. Trees change considerably through the seasons and you will need to study them on many different occasions — in full leaf, flowering, fruiting — to increase your knowledge and become fully confident.

Figures 19 and 20. *Studies of trees, both bare-branched and in full leaf.*

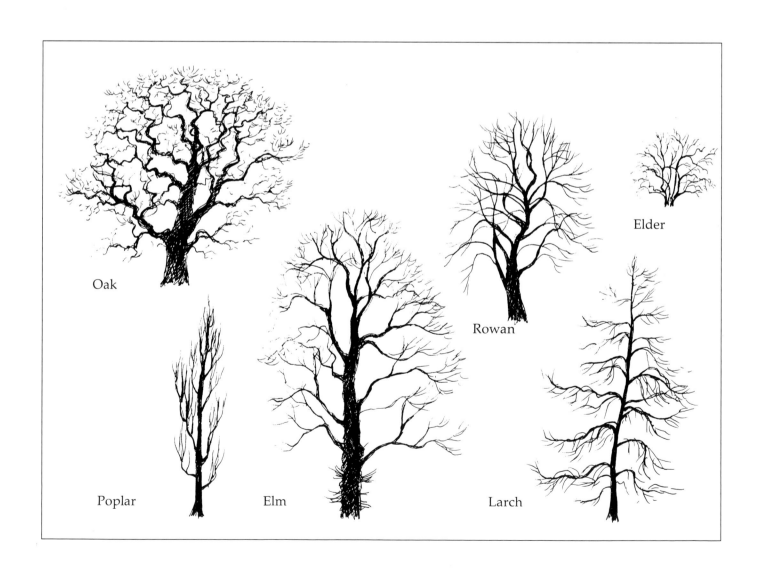

Oak

Poplar

Elm

Rowan

Elder

Larch

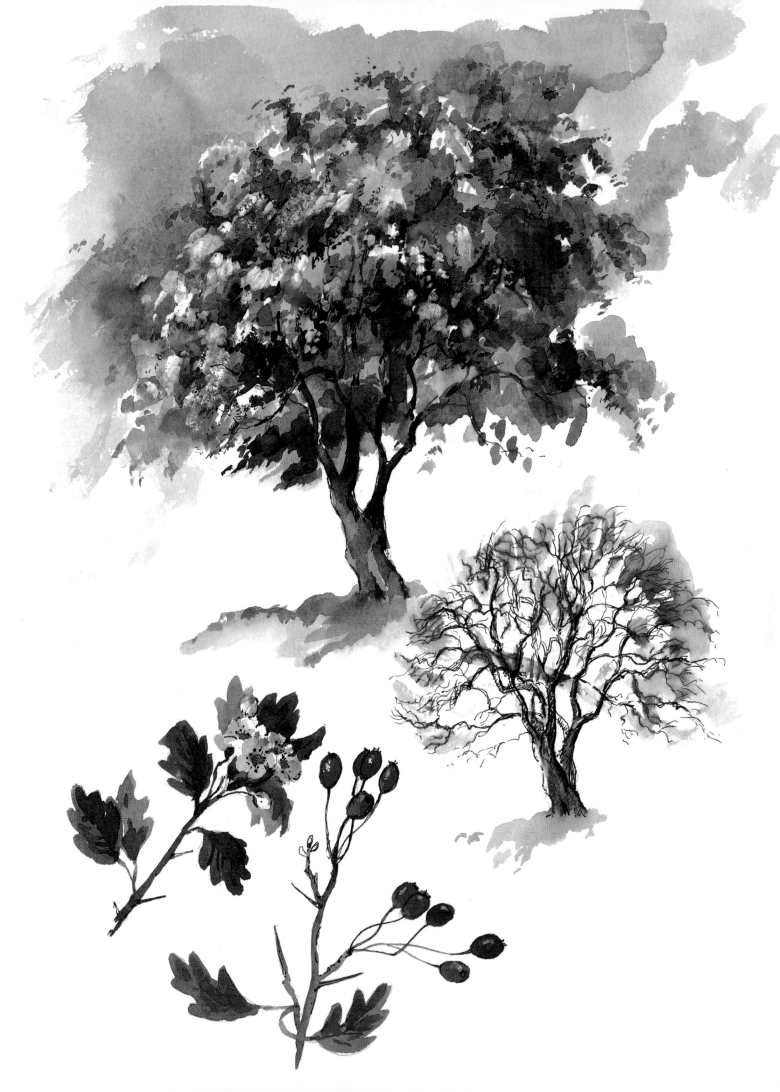

SILVER BIRCH IN AUTUMN

Materials

Masking fluid
Watercolours (red, yellow
ochre, blue, deep violet)

(a) Apply masking fluid to
highlight appropriate
areas.
(b) When it has dried,
apply gentle washes of
green and orange,
highlighting the main areas
of bark and creating the
impression of distance with
a pastel shade of violet.
(c) When the washes have
dried, rub off the masking
fluid to expose the white
bark. Mix a puddle of
darker paint, using violet

and green, and paint in
points and dashes to
represent the roughened,
darkened wood. Add
details of small leaves,
softening and punctuating
the tree's outline with your
rigger brush.

Figure 21. *The silver birch is painted
in three stages.*

a b c

COMPOSITION AND TONAL STUDIES

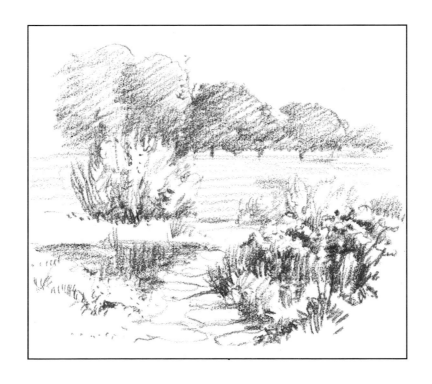

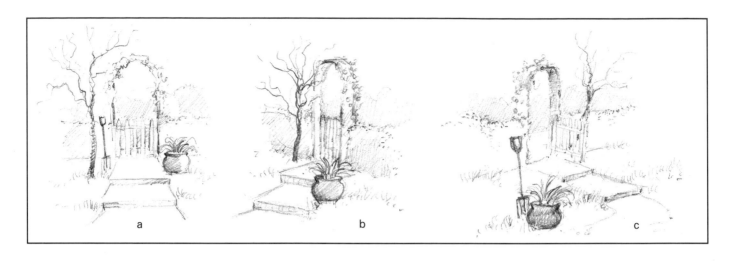

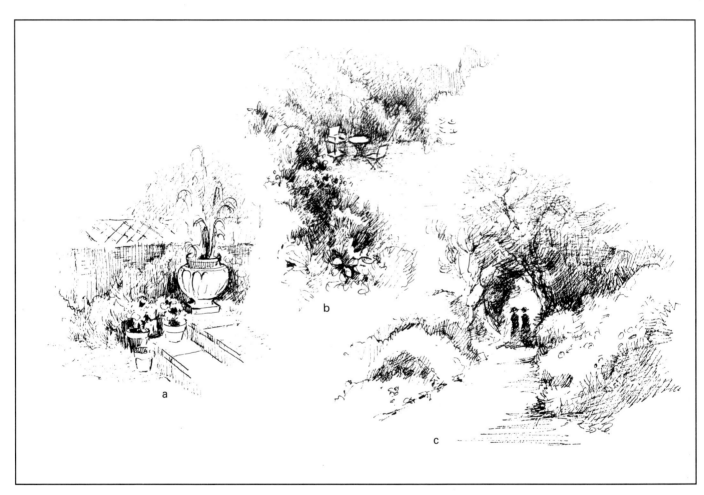

Figures 22 and 23. *These sketches show the importance of good composition.*

COMPOSITION AND TONAL STUDIES

There is a science within art. Every picture conveys a feeling of 'right' or 'wrong' the instant we look at it, and when things seem wrong it is frequently a fault or problem with the composition. Rarely does nature present a perfect composition to us; the act of transferring a three-dimensional reality to a two-dimensional plane usually involves some rearrangement or adjustment. The artist has to develop his facility for conveying rhythm, design and interest within his chosen space.

A focal point is essential in every painting. Usually it is the area or item that has inspired the artist in the first place. You should certainly not place it in the centre of the canvas, and you may need to move the horizon up or down in order to avoid cutting the picture in half. When you have found a scene that you wish to paint, walk round and view it from various angles. Use your viewfinder (see page 7) to note the changes of form and perspective that will be revealed by these slight alterations of position.

As artists, we are free to translate and express our enthusiasm exactly as we wish, making our final composition very personal and no doubt reflecting our previous efforts and experience.

ARRANGING A COMPOSITION

You need not be restricted to merely reproducing a scene faithfully from nature. Great pleasure can be derived from creating additional interest and harmony within that given space. In the sketches of a garden path (opposite, above), I have tried to illustrate this point:
(a) A frontal viewpoint with the objects spread about. Definitely a boring composition!
(b) Here things look a little better. The objects form a compact and interlocking design. From this gentle angle, the arch and steps start to look more interesting. I have purposely left the fork out of this

sketch; it often pays to question whether objects like this need to be included in the design.
(c) The original objects are used but the urn and garden fork have been arranged in a different way. The path is sweeping in from the right, leading the eye round the composition, adding to the rhythm in the picture.

The focal point of a painting often only occupies quite a small area. The rest of the picture can be seen to perform a secondary, supportive role, which must not intrude or clash. However, it need not be dull or boring. In the ink sketches (opposite) I have emphasized these points.
(a) The urn is supported by the vertical, horizontal and diagonal lines created by the steps and fence.
(b) The garden furniture is surrounded by lovely rhythmical foliage shapes. The most uncluttered element is the lawn, while the busiest and most active area is in the foreground, leading up to the focal point.
(c) The distant figures are emphasized by the deep-

shadowed areas, contrasting with the light, and these in turn are helped by the undulating lighter foliage in the middle distance. The figures are also stressed by the large blank area leading up to them in the foreground.

Select a scene and produce at least three drawings from it, varying the angle so that the objects in your pictures appear in different positions. Decide which you like most and why. Learn to do this whenever you see what appears to you a good subject for a painting. Your sketchbook will prove invaluable here, both as a permanent reminder of lessons learned and as a storeroom of ideas to supplement a composition in need of an extra prop not present in reality.

Figure 24 (left and right). *Props can be an attractive feature of a painting, and should be recorded in your sketchbook for future reference.*

RHYTHM IN COMPOSITION

Borrowed from the vocabulary of the musician, the word 'rhythm' when used by an artist usually refers to the way in which the painter attempts to lead the eye into and around the painting before it finally rests on the focal point. Keeping the onlooker's attention requires skill — without rhythm, interest would soon be lost.

Violent lines and discordant angles lead the eye out of the painting but gentle curves, swaying lines, zigzags and subtle arcs will give a harmonious movement. If you study my ink sketches opposite and on this page, you can see the simplicity of the basic shapes, which all relate to letters of the alphabet: C, O, S, T, U, V, Z.

If you discover a satisfying formula for a painting, perhaps a tall tree left of frame with its branches coming in from the top, punctuating the sky, try to resist using the same structural

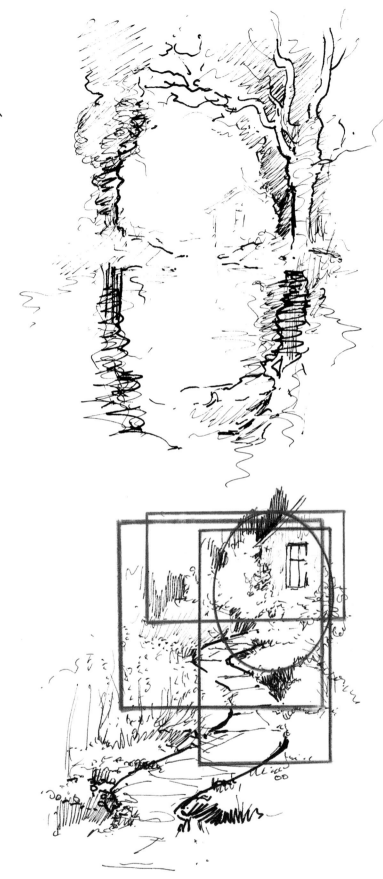

concept again and again in other work. Keep experimenting — don't be predictable. Try subdividing your work as I have done here with squares, rectangles and ovals to find other, quite different compositions.

TONAL STUDIES

Let us now turn our attention to another vital ingredient, the portrayal of tones. The range of tonal values in nature is almost infinite and, as artists, we will have to compromise and adjust what we see. In the key which accompanies these three tonal sketches I have used a 6B graphite pencil to show six tones between white and black. Note the deep velvety tones for shadows and dark areas, and the light soft tones for the areas touched by sunlight. Try to imagine your scene as a jigsaw puzzle, with the areas of tone lending support and contrast to each other. If time is limited or the weather threatens to change, you can quickly use a number system like mine in Figure 27 to give you most of the information you will need later on.

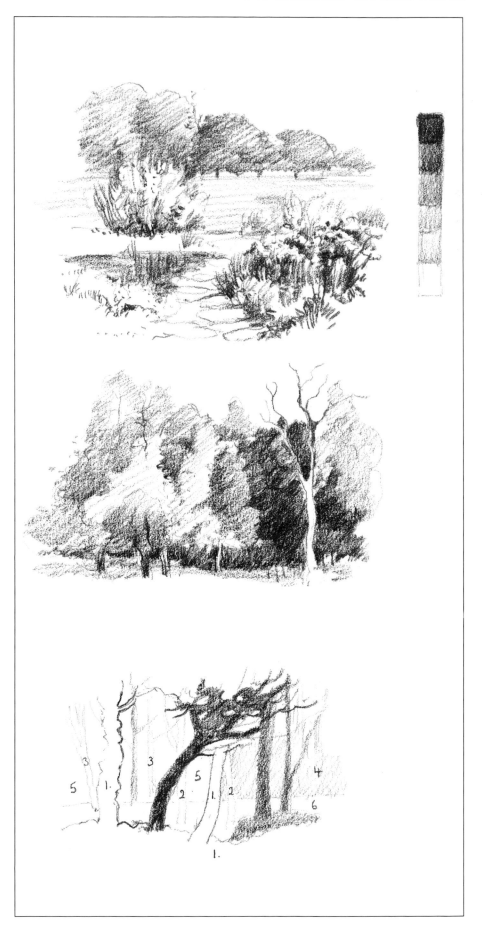

Figures 25–27. *It is important to make tonal studies when sketching nature subjects.*

CONTAINERS AND
OTHER PROPS

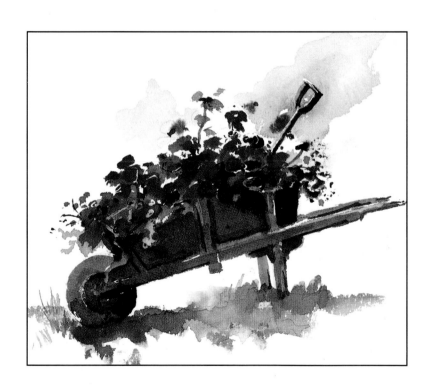

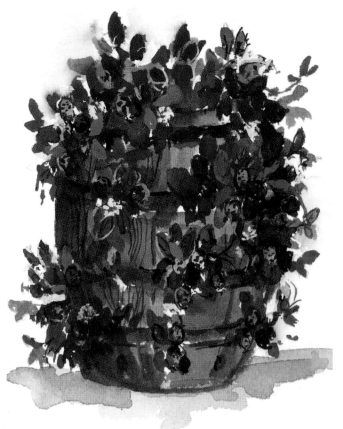

Figure 28.

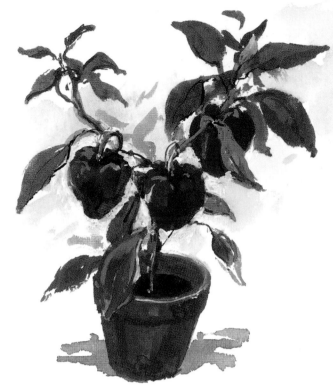

Figure 29.

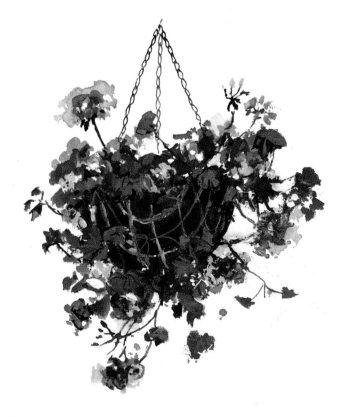

Figure 30.

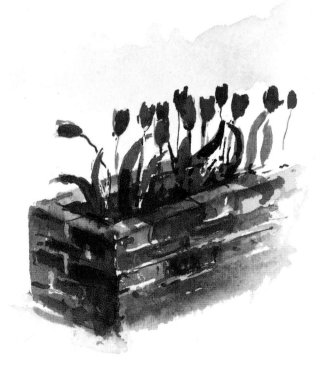

Figure 31.

CONTAINERS AND OTHER PROPS

Many of us grow indoor plants in attractive pots, jugs and even chamberpots! These make charming focal points, and seem quite at home in all sorts of places. On the floor, on steps or windowsills, they create interest in odd corners and offer special opportunities for trailing plants. The most unlikely containers can find themselves as lifelong partners to a plant and often present intriguing objects for a painting.

Sometimes the containers or their plants call for bold treatment and then I will use gouache, or gouache over watercolour. Gouache can be applied thickly, obliterating underlying colour completely. Just like oils, even light colours can be applied over dark, eliminating the need to work from light to dark as with watercolour.

The strawberry barrel opposite makes a homely and decorative container (Figure 28).

Figures 28–31. *Plant pots and containers create interest and often call for bold treatment.*

Yellow ochre was applied as a first wash to give it warmth. Brown gouache was then added with a small rigger brush to give the barrel body and detail. The bright red fruit makes a delightful foil to the green foliage.

The plump peppers in Figure 29 make an excellent still-life study. The strong colours are in gouache, with highlights in white and pale greens.

A hanging basket is ideal for softening the hard edges of walls and doorways. In Figure 30, I started with dark pink shapes and then added the sunlit blocks, again with thick gouache. White gouache was introduced between the flowers to add light and interesting shapes.

Spring bulbs make a lovely display. Deep red and oranges were used for the wall of old textured bricks in Figure 31.

The cheeky pottery birdhouse in Figure 32 (overleaf), made by a friend of mine, is always a source of joy, especially in summer when it is clothed by white clematis. I used masking

fluid on the pale flowers to preserve their brilliant whiteness. The details of the woodwork, tapering buds and leaves were painted in with gouache.

I painted the wheelbarrow in Figure 33 from a photograph. Starting with a green watercolour wash, I then added yellow ochre in places to create the sunny effects. Thicker red gouache was used for the geraniums.

As well as containers, gardens often include many other man-made objects, both decorative and functional, that I think of as props. These can also be a source of inspiration for a painting, complementing the plants. Take a stroll down your garden path and note any objects or features that have the potential to add interest and atmosphere.

Do a few sketches and do not overlook the value of a camera. I am always using mine in this way, quickly collecting lots of ideas and allowing myself the freedom of drawing from them later. A 35 mm reflex camera with a zoom lens will cope with

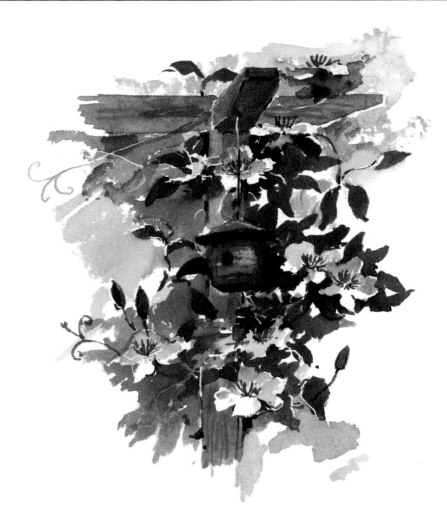

Figure 32.

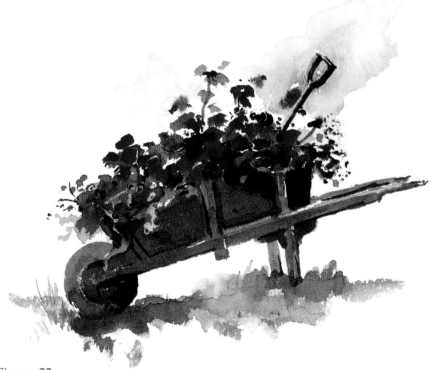

Figure 33.

everything from close-ups to quite wide scenes. For sketches like these, I encourage my students to try the soft aquarelle pencils. They are fast and their intricate, subtle effects lend themselves well to portraying the weathered quality of garden objects. Just as with paints, two colours can be blended or even cross-hatched to produce another. Always work from light to dark and keep the pencils sharp. Mistakes can be erased with a putty rubber.

I was attracted to the rugged birdhouse in Figure 34 because of its texture and simple form. I sketched in the basic shape with a blue pencil and filled in the weathered boards with a mixture of brown, violet and pink pencil strokes. The foliage was drawn in with orange and green, and slightly wetted to blur the image.

The rusty old roller in Figure 35 was rapidly sinking into the long grass. I treated the body work with dry blue, brown and pink pencil strokes. The surrounding greens were washed over, giving a mistiness to the distance.

The neat stone sundial in Figure 36 stood erect and strong against a deep foliage background. I used olive-green watercolour for the background area, and pencil work in blues and violet for the sundial itself. Watercolour splattered with my toothbrush on the ground gives a pebbled look.

I drew the delightful stone figure in Figure 37 in green and violet pencil work. Then I carefully washed over certain areas with water, blending the colours together. Blue was taken directly from the pencil's point and applied to the background with a brush.

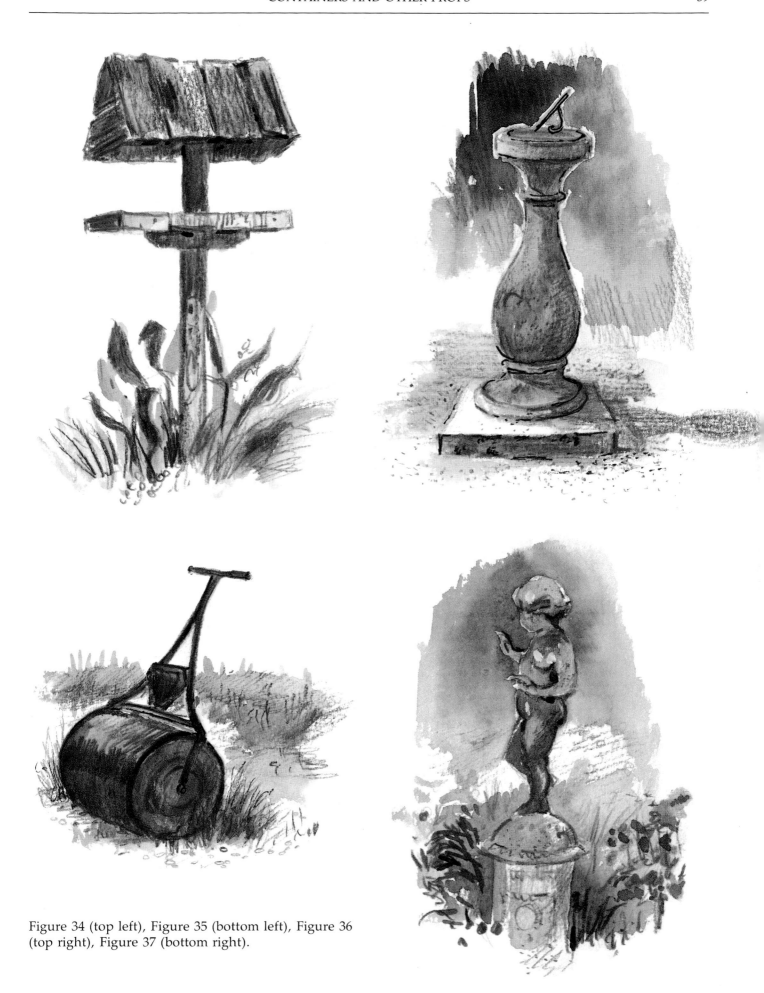

Figure 34 (top left), Figure 35 (bottom left), Figure 36 (top right), Figure 37 (bottom right).

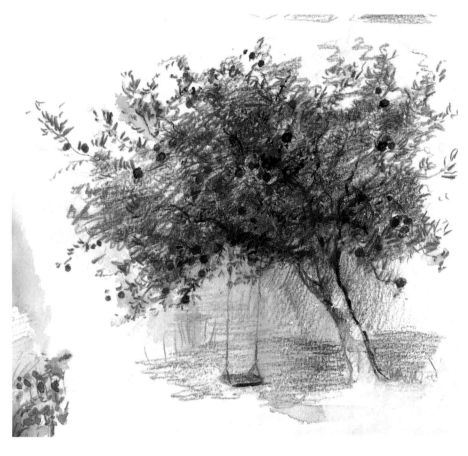

GARDEN FURNITURE

Not a natural feature of a garden, many kinds of garden furniture can offer peaceful, and sometimes offbeat, elements in a painting. Strategically placed, like the other props I have already discussed, they make attractive additions and allow you scope for arranging the scene to your advantage. My 'fat-bellied' deckchair with its sleeping cat (Figure 44 on page 42) is an example, but you can also consider hats, newspapers or other miscellaneous objects casually resting on a tabletop.

In these studies, I have worked in ink in various forms for the tonal studies, using felt-tip pen, fine steel-tipped pen and a dipper or cartridge pen with black non-permanent ink; sepia or vandyke brown ink would be equally suitable. I also used a black 'watercolour' brush and masking fluid. Studies such as these not only test the artist's skill at judging tonal values, but his or her draughtmanship as well!

The gentle circular outline of the umbrella in Figure 40 echoes the shape of the tabletop and adds a certain 'style' to this picture.

The lace-like pattern of the woven chairs and tablecloth inspired the study in Figure 41. I used masking fluid for the lacy effects and objects on the table, washing over the whole with varying tones of ink.

I used the same technique as in Figure 41 for Figure 42, using masking fluid to create the structure of the hammock before applying the darker background ink wash.

The richly laden apple tree and swing above were ideal props to draw with aquarelle pencils. I used strong marks of blue, green and violet cross-hatched to form a stable mass of foliage, and light red and violet for the branches. A little water was added in places to the foliage to soften it. The red apples were added last of all.

I discovered the rustic overgrown pump (right) in a student's garden. The grey metalwork was built up with dry cross-hatching of blues, browns and violet.

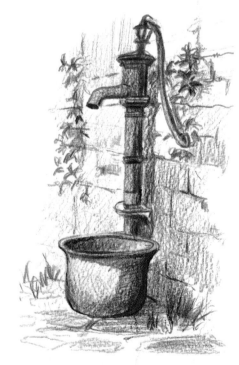

Figures 38 (above), 39. *Unusual features can be used to create interesting sketches and paintings.*

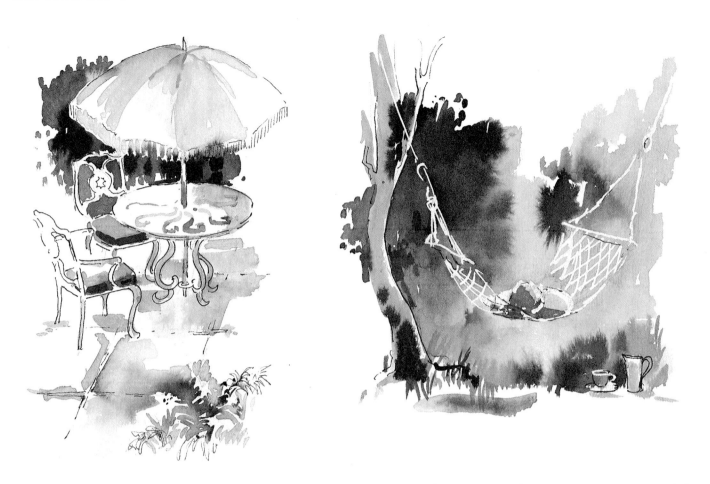

Figure 40 (top left), Figure 41 (below), Figure 42 (top right).

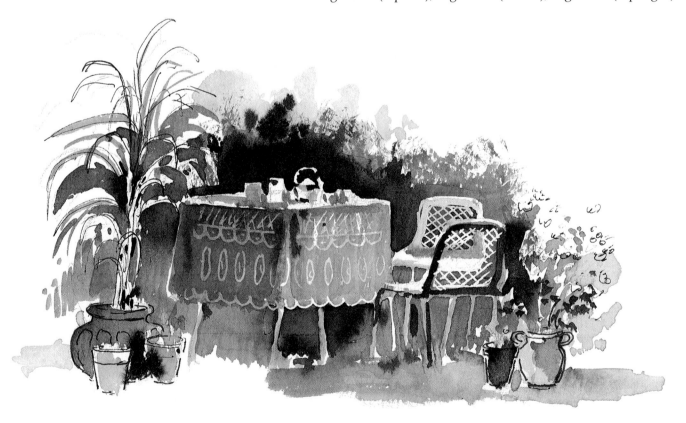

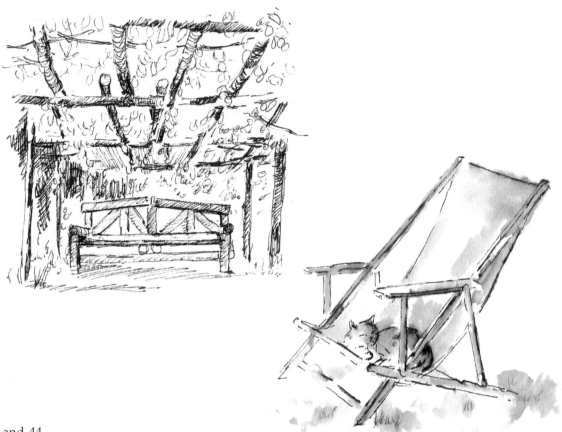

Figures 43 and 44.

The chunky timber seat in
Figure 43 was sketched in with a
fine-tipped drawing pen.
Various textures were built up
using different kinds of strokes
and marks.

In Figure 44 water was
washed up to the fine felt-tip
work of the deckchair and cat,
allowing the ink to run and flow
into its surroundings. This
technique may need some
tidying up and strengthening
afterwards.

In this scene in Figure 45, your
eye is led from the ivy-covered
tree, through the slatted wooden
benches and table. You can use a
wide felt-tip or a black
watercolour brush for the tree
textures. Further delicate ink
washes were applied to the
background, highlighting the
lighter parts of the table and the
edge of the tree.

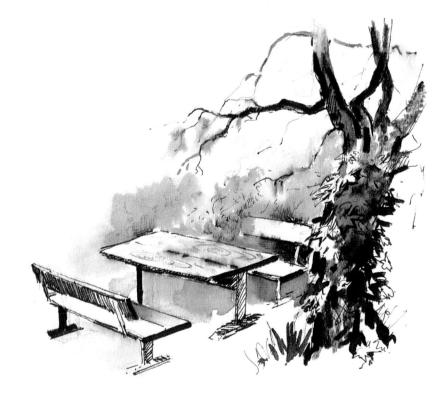

Figure 45.

SPECIAL FEATURES

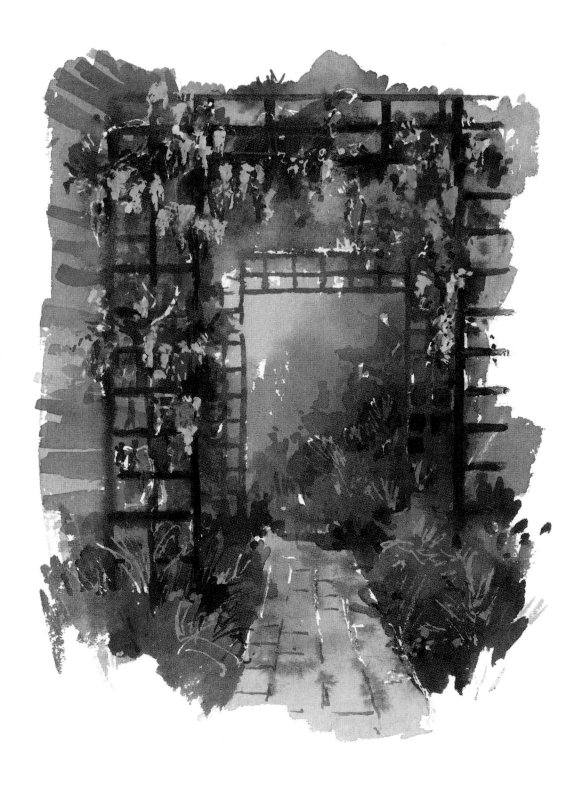

Figure 46. *Wisteria covers a plain wooden trellis.*

SPECIAL FEATURES

CLIMBING PLANTS

Climbers are among the most beautiful and versatile plants in any garden. They can disguise the most ugly eyesore with flowers or foliage, or transform an otherwise plain and boring feature. Climbing plants add extra beauty to trellises, arches and textured walls. From an artist's point of view, they soften and blur hard edges and angles. Like trees, they provide height and interest in a painting. A garden where all the colour and detail is at ground level is unlikely to inspire a balanced painting.

The following watercolour studies are from my sketchbook and were painted in friends' or students' gardens.

A wooden trellis provides support for the gorgeous wisteria opposite, which transforms an otherwise blank wall into a spot of sheer

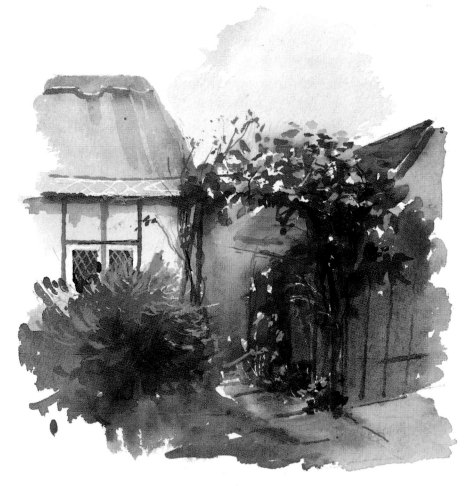

Figure 47. *A rose arch adds beauty and colour to a quiet corner of the garden.*

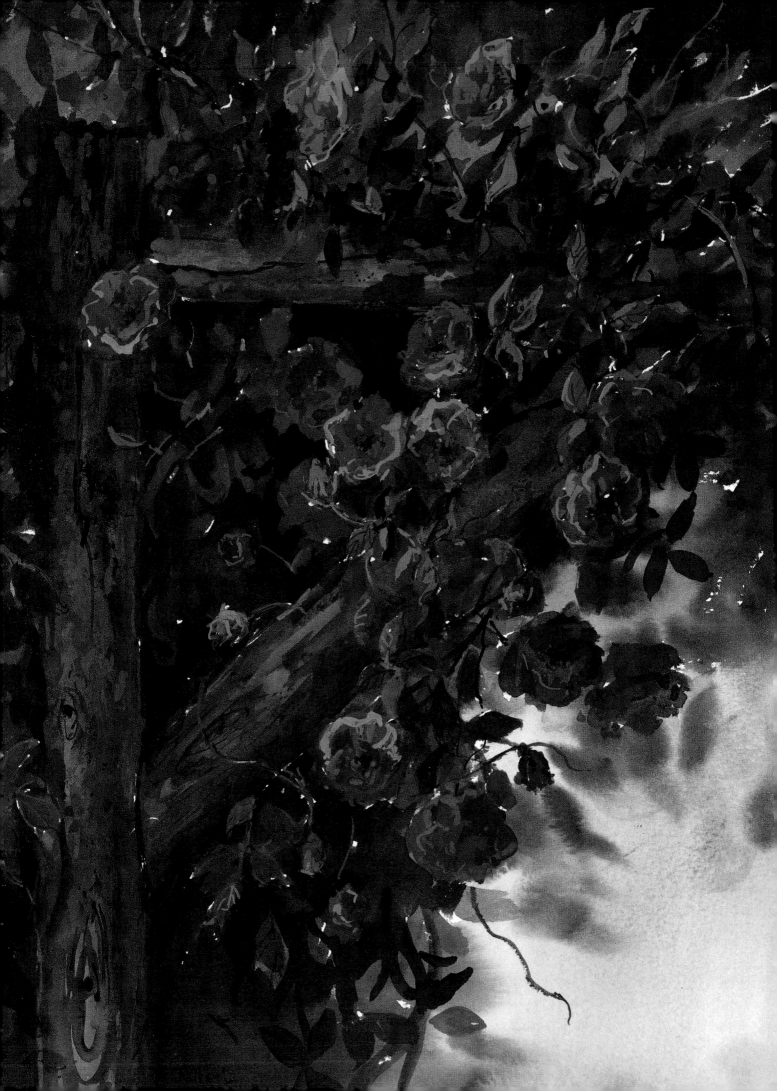

Figures 48 and 49. *Watercolour and gouache are combined to create the colours and textures in the roses opposite and the runner beans below.*

terre verte for the cold green bush on the left.

The watercolour and gouache painting opposite (Figure 48) shows a climbing rose clambering through an arch. The rough weathered look of the wooden supports was achieved by splattering paint from an old toothbrush, and by painting the gashes and markings in ink, using a Japanese brush.

A simple wooden wigwam, covered with runner beans, shows the opportunity given by a humble subject (Figure 49). The long beans were painted in light green gouache on top of a darker blue and green watercolour wash, avoiding the need for too much masking fluid. The bright red flowers were also painted in gouache, and created lovely 'punchy' dots of colour in contrast to the greens.

EXITS AND ENTRANCES

For a long time I have had a fascination for gates and doorways. Our curiosity is aroused by what we cannot see; we wonder what is inside the half-open door, or through the garden gate. They attract the eye and tantalize the imagination.

I am constantly surprised at the individuality of their shape, design and structure. As an exercise go out and look around your neighbourhood. You should soon have enough sketches for one or several paintings. However, in order to be successful, a painting has to appeal as a unified and harmonious 'whole'. Doors and gates may contrast quite starkly with their surroundings, making them jump or leap out at you.

beauty. Note how the trellis and flowers create the rhythm in the painting by leading the eye up across and down the other side. You will soon discover that painting flowers demands a few special colours that will prove impossible to mix, Scarlet lake or permanent rose and the permanent magenta

that I have used for the vivid pink wisteria, for example.

The climbing rose on page 45 has taken on the shape of the arch which no longer really supports it, making a delightful link between the two buildings. At the top was a profusion of lovely fragrant red roses. I used olive green for the foliage and

One way to avoid this problem is to carry the colour of the surrounding area or objects into the subject and vice versa. This tip will help you with any other subject that presents this problem.

The elegant wrought-iron gateway in Figure 50 provided a natural frame for the patio beyond. The dark surround and grey brickwork is painted in gouache, exaggerating the lighter 'peephole' effect.

The cosy wicket gate in Figure 51 is a focal point of this scene, with the cottage behind as a supporting feature. Note the use of violet, blue and green across the gate and doorway, binding the whole composition together and creating harmony with colours that would otherwise be in too stark a contrast.

In the painting opposite of an old farm door, slightly ajar, I wanted to express the mysterious invitation of its hidden depths. At the same time, mellowed brickwork and a heavy canopy of ivy needed to be strongly painted to prevent the interior being too dominant. I used a mixture of gouache, watercolour and ink. The door was drawn in first in sepia ink, with gentle washes of watercolour on top. Dry brushwork was used on the bricks to imitate cement.

Figures 50 and 51. *Gateways often provide interesting glimpses of gardens beyond and can be used as a focal point in a painting.*
Figure 52 (opposite). *An old farm door surrounded by ivy contrasts strongly with the rough weathered woodwork.*

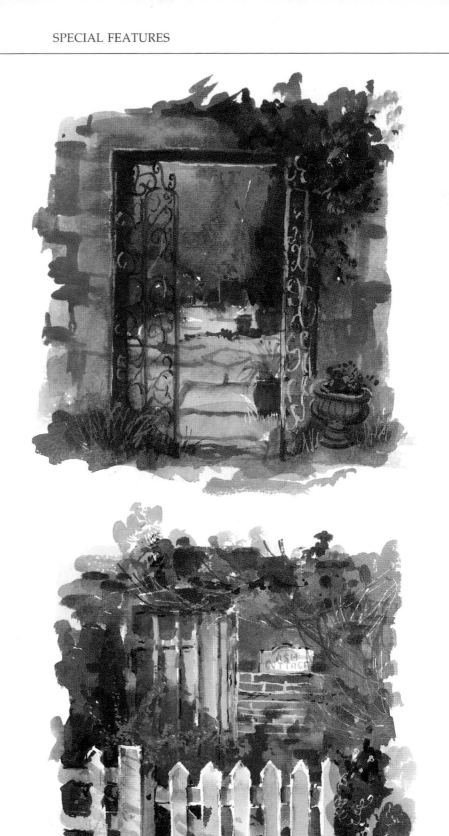

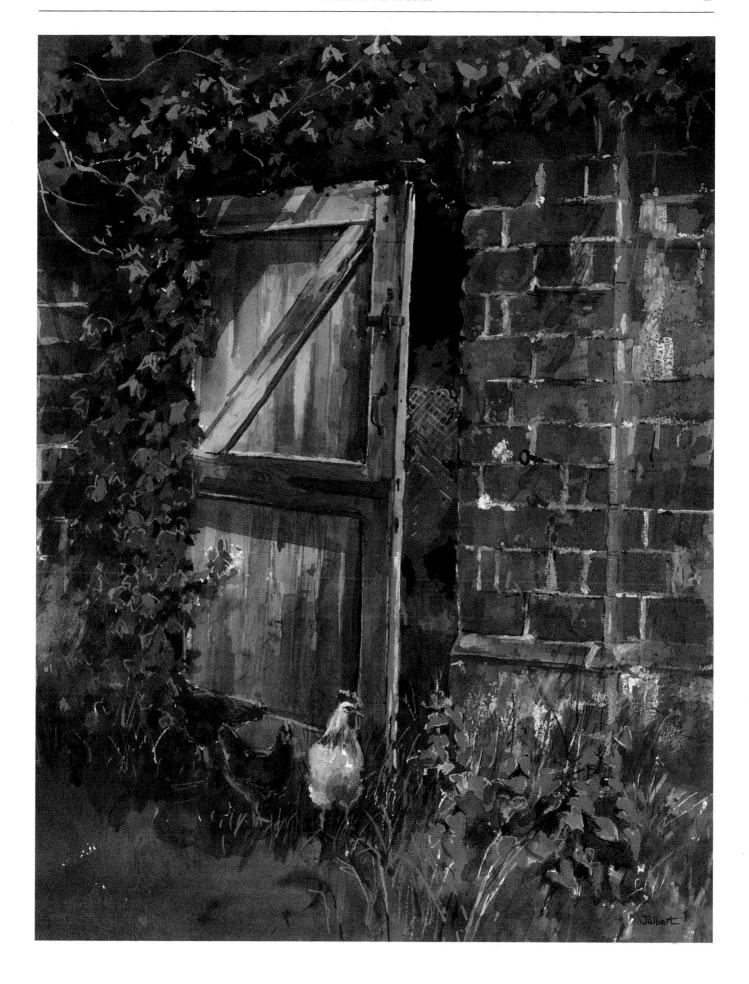

SUPPORTS FOR YOUR PLANTS

In my sketchbook I have dozens of studies of posts, hinges, locks, nails and other countless details from outdoor surroundings (see below). These are absorbing subjects in themselves and, when needed, they provide structural and technical information, both in landscape paintings and as supports in my flower pictures. If you are going to include a post or part of a fence, a little research is essential.

As an exercise, you may like to tackle this step-by-step of a convolvulus climbing up a gatepost.

Materials

Masking fluid, watercolours (olive green, yellow, light red, cerulean blue), white gouache

(a) I arranged an intertwining strand of convolvulus in natural surroundings to show off its soft fragility and timid beauty.

First, pencil in some details as guidelines. Keeping the watercolour fluid, wash in the main areas of the background in blue, then the centre in yellow and light red, and the foliage in olive green. Leave the outside of the flower untouched.

(b) Continue to paint more details by darkening the centre, the bud and leaf.

(c) Finally, add the last central details with a rigger brush in green and light red, and indicate the leaf and bud texture in dark green. Add white gouache to heighten the flowers' delicate structure.

(d) When I had finished the small study, I carried out a detailed painting of the whole strand (opposite, below) to capture the delightful way in which the leaves and flowers grow, twisting and turning almost as if they are dancing.

The finished painting (Figure 55) is shown on page 52.

Figure 53. *Sketchbook studies of garden details. Posts, hinges and wire provide useful reference for future paintings.*

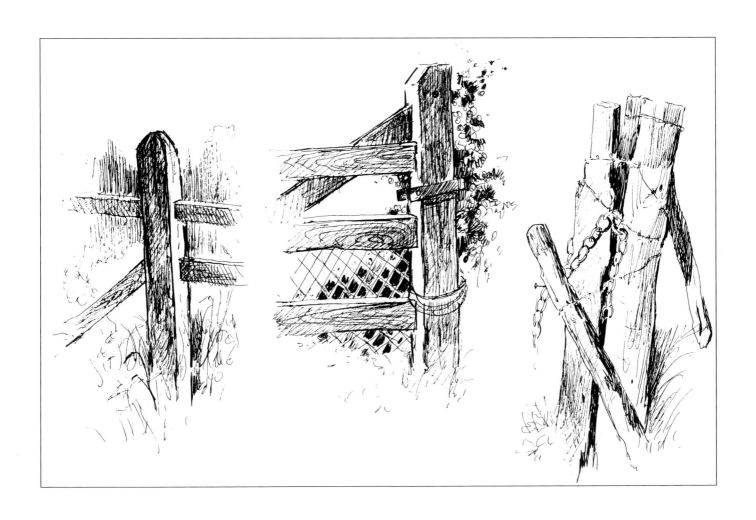

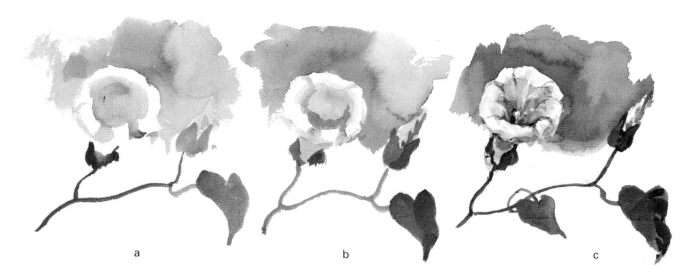

a b c

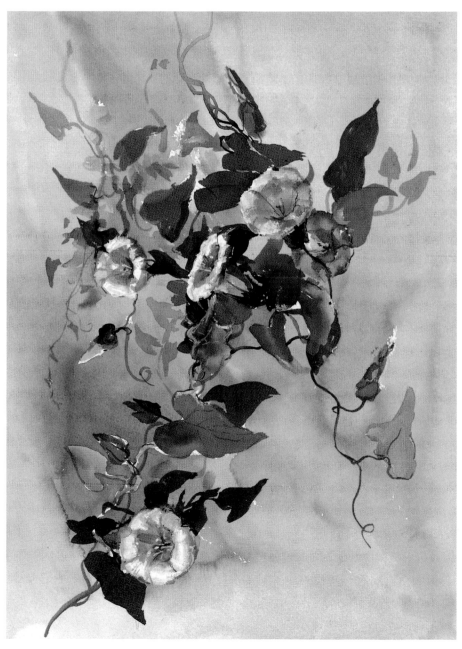

Figure 54. *The intricate twists and turns of stems and flowers are illustrated in this painting of a convolvulus climbing a gatepost (see finished painting overleaf).*

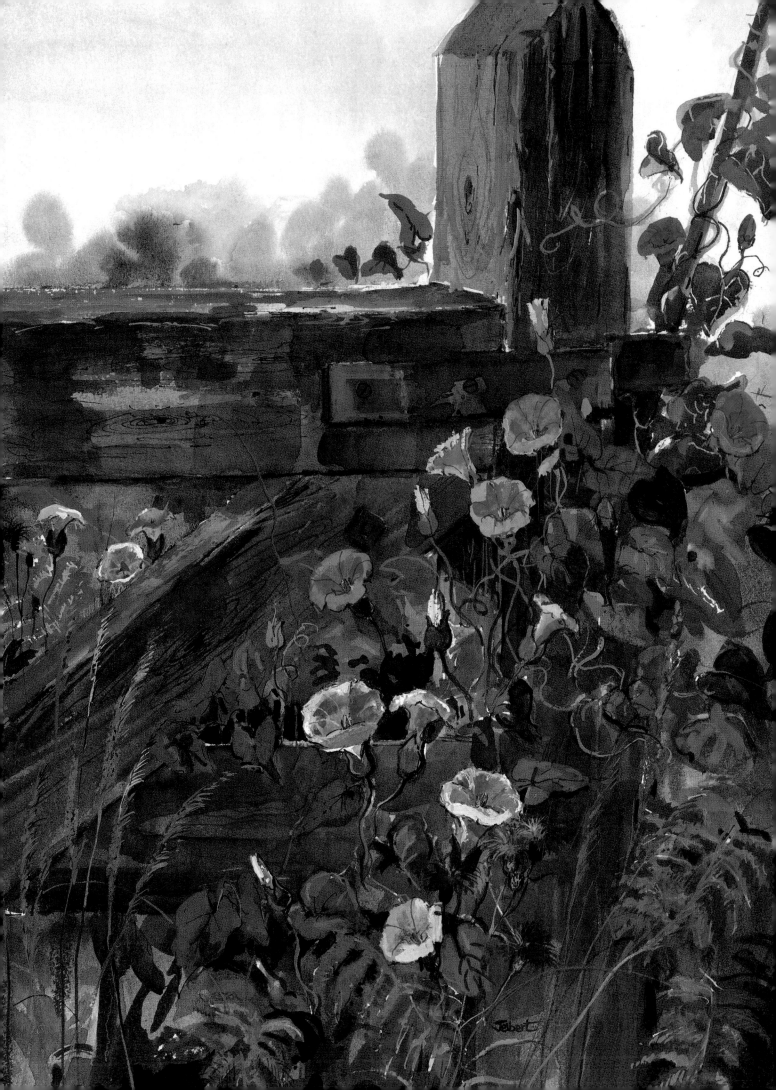

BALCONIES, HERB GARDENS AND WINDOW BOXES

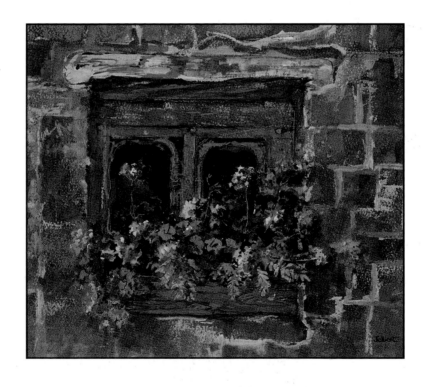

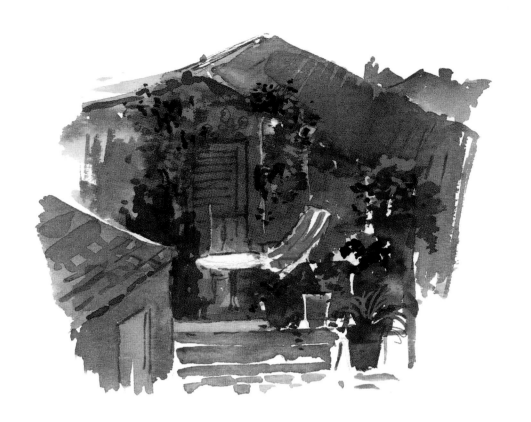

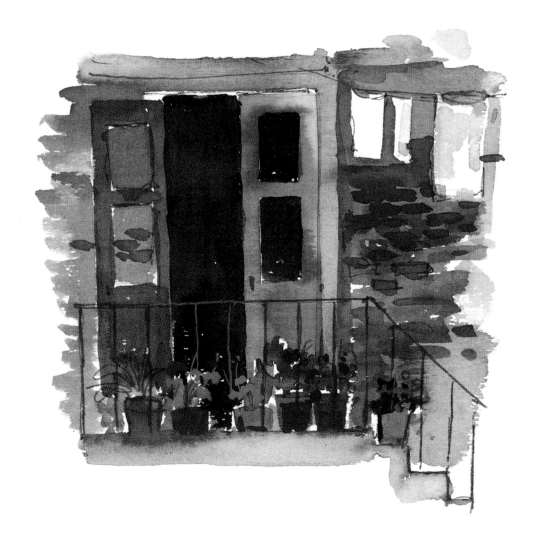

BALCONIES, HERB GARDENS AND WINDOW BOXES

In towns and cities, a balcony or roof garden may be one's only, greatly valued, retreat. For the artist, too, it can provide sufficient scope for many hours of painting. Terracotta, china and wooden containers of all shapes and sizes, crowded with dwarf evergreens, flowering creepers, and hardy and annual plants, hide the hard lines of masonry and concrete, and unsightly views. This quiet oasis will allow privacy for artistic activity close to the comfort of your own flat or house.

Part of the view could perhaps be used as a background for a painting. Exploit the available vertical spaces and encourage climbers to invade these architectural heights like a 'jungle-in-miniature'. This could either be the main subject in your painting or a supporting feature to the distant view.

Figure 56. *Three paintings showing how small areas such as roof gardens, staircases and balconies can provide inspiration and interest.*

THE HERB GARDEN

In the past decade there has been a great revival of interest in growing herbs for medicinal, culinary and nostalgic reasons. With their rich harvest of pods, seeds, roots and leaves, they remind us of the days when bunches of herbs hung from ceilings in flagstoned kitchens, filling the air with their lingering scents (opposite, above). You may be fortunate enough to see a medieval herb garden, a 'knot garden', planted in precise mathematical sections bordered by little hedges of box, cotton lavender or hyssop. Originally, religious symbols such as a star or ladder shape were used as the design, using lawn or gravel strips to separate the various herbs. An island of herbs — high, stately foxgloves, spiky banners of lavender, blue-green artemesia, yellow woad and pink chive pompoms — form a lovely mound of texture and colour (below). I used a sepia water-soluble ink in a steel-nibbed pen with washes of watercolour and gouache. The ink dissolves beautifully when touched with water, adding a nicely diffused quality to the darker areas.

A triangular (a) or triquetra shape (b) often filled an awkward corner (opposite). A maze, circular or cartwheel design (c) frequently included a statue or sundial in the centre. The selection of herbs would have included the large-leaved sage, wispy tarragon, bright green mint, crinkly thyme and fern-like fennel. In (c), I decided to use tall spikes of lavender, offset by tufts of golden marjoram, mint and golden thyme.

Herbs can be grown in containers — in strawberry barrels, window boxes or sink gardens — or alongside other plants. They make a heavenly setting, wafting a relaxing fragrance over the artist at work!

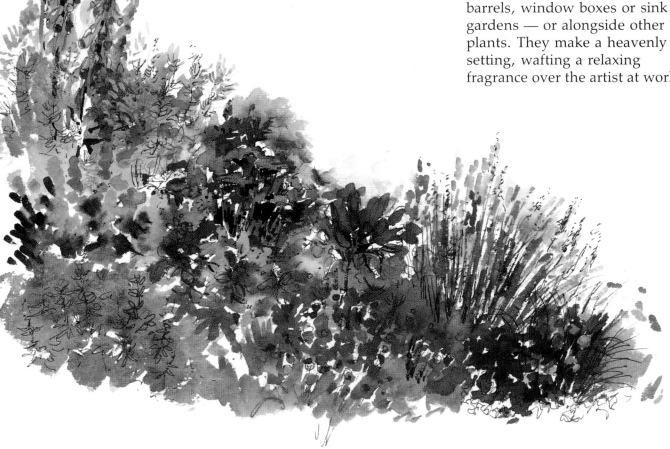

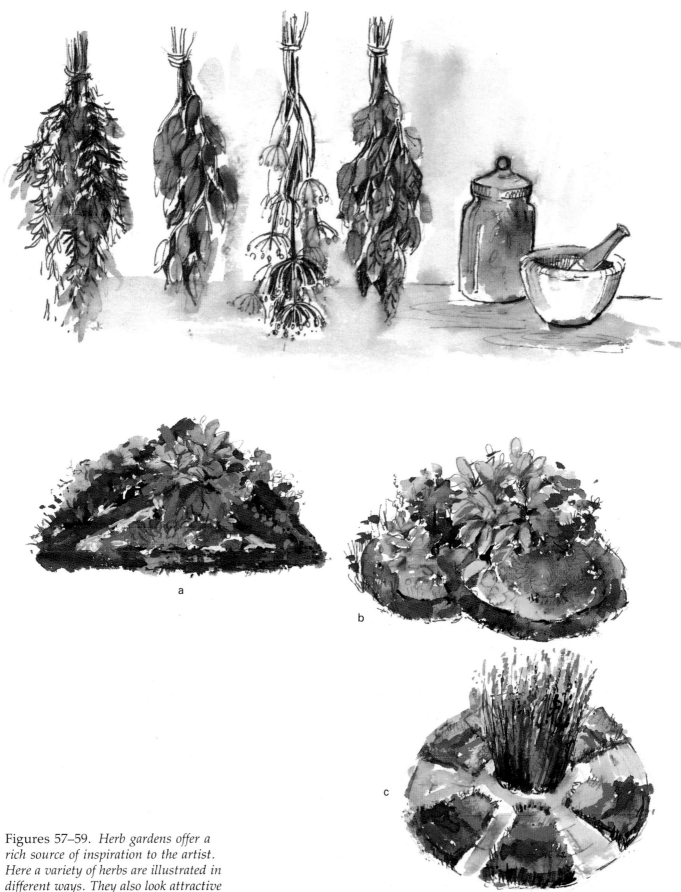

Figures 57–59. *Herb gardens offer a rich source of inspiration to the artist. Here a variety of herbs are illustrated in different ways. They also look attractive growing in pots and containers.*

WINDOW BOXES

Even if you do not have a balcony, let alone a garden, lack of space need not deter the artist or gardener from expressing his or her creative flair and love of nature. Window boxes, full of brilliance and variety, are a most colourful adornment to a building, the windows behind supplying the perfect backcloth or 'stop'. Lace curtains, reaching out through a half-open casement in a gentle breeze, or a hint of domestic atmosphere created by ornaments on the windowsill inside can give a painting a warm, homely feel. A windowsill is also irresistable to a cat and offers an opportunity to include one in a very natural setting. Other ideas will come to you if you search through the props you have collected in your sketchbook.

I have used the rough, weathered walls of a country cottage as the main support for the window box painting below. I started with a strong watercolour wash of raw umber over the entire stonework area. When that had dried, I applied oil pastels in ochre and light grey in places to give the 'broken' textured effect. The window frame was painted in light and dark grey watercolours, and touches of yellow ochre were applied with a rigger brush. I used ochre oil pastel in broken strokes to 'age' the wood. Permanent magenta watercolour was used for the geraniums that spill from the box. Olive green and deep violet watercolours were used for the dark area inside the window, contrasting beautifully with the flowers.

Figure 60. *Rough, weathered stonework contrasts strikingly with a colourful window box.*

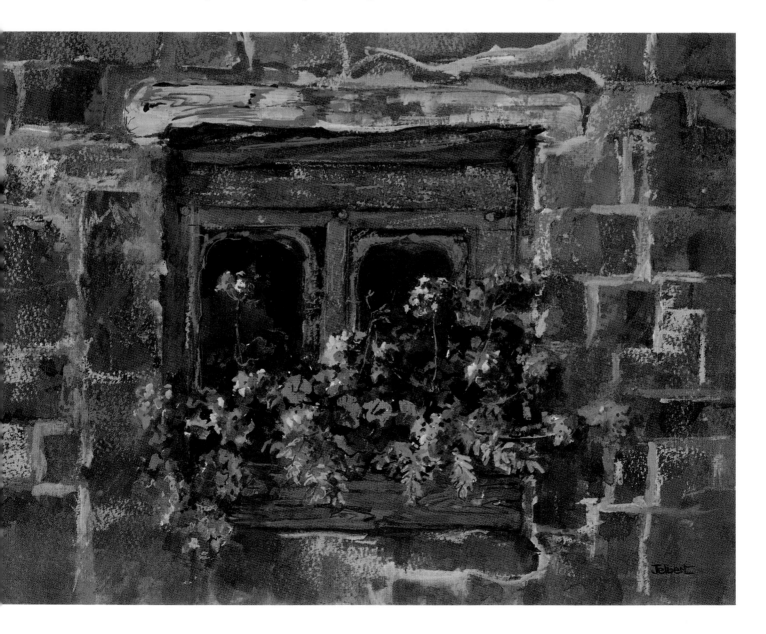

A LARGE GARDEN

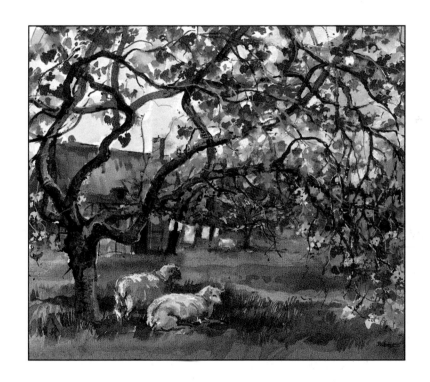

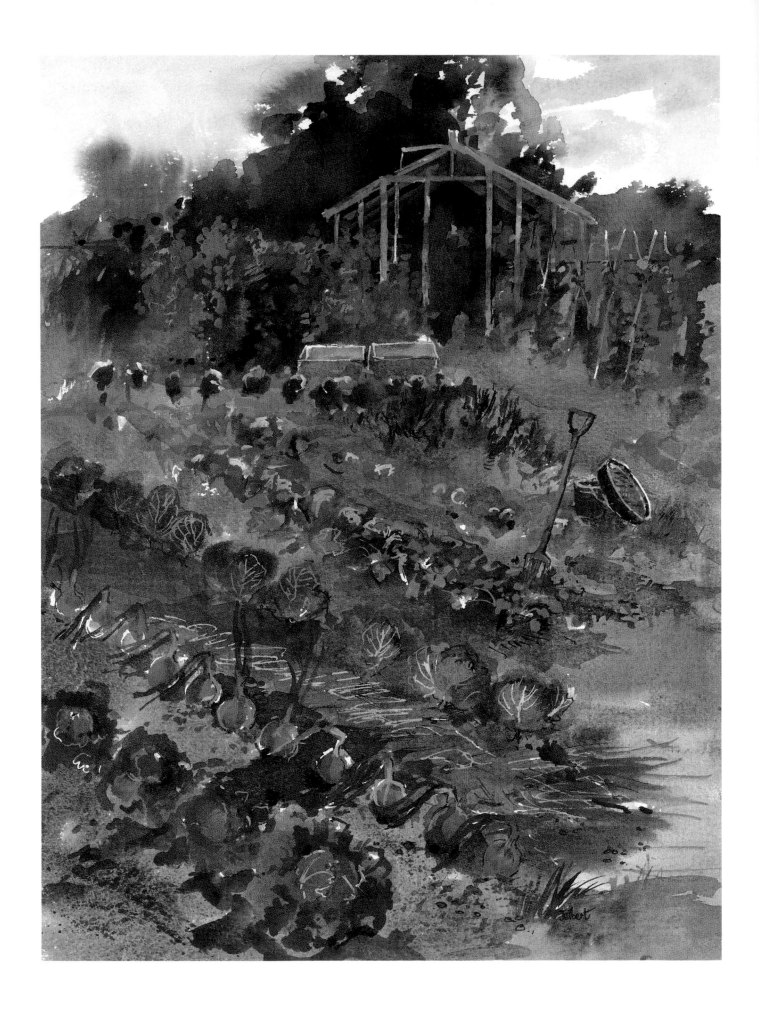

A LARGE GARDEN

Larger gardens are often divided into specific areas, each with its own quite distinct atmosphere.

THE VEGETABLE PATCH

There is something very satisfying about a vegetable garden, exuding, as it does, an air of simple self-sufficiency, particularly when the soil is rich with an abundant crop. In the watercolour painting of my summer plot (opposite) I used sap green and yellow ochre for the plump lettuces in the foreground and violet and red for the earth surrounding them. The yellowy pink mounds of onions and their wayward tops show up well against the loose scattering of straw. The textured look was achieved with dashes of masking fluid before the ochre

Figure 61. Garden tools and a greenhouse in the background add an extra dimension to the neat rows of colourful vegetables.

wash, followed by slight dashes of ink for definition. Masking fluid was also used for the veined effect on the cabbage leaves, before washing over with reds and blue-green. A spattering of sepia ink mixed with violet watercolour gave the freshly tilled-earth appearance in the left foreground. Ink in small touches was also used to emphasize important shapes and objects. Spots of interest can be created by the careful placing of odd tools, pots or, as in the picture, a coldframe.

I merged the greenhouse into the dark background foliage, using deep blue-green, as it seemed a good stable prop that blended well into the middle distance. Beanpoles carry the vertical composition towards the angle of the fork and this, in turn, offsets the strong angles of the neat rows of vegetables.

I have included a study of the different varieties of chrysanthemums found in my greenhouse (see page 62). With a little planning, a greenhouse can provide artistic interest throughout the whole year!

ORCHARDS

In Figure 63 on page 63 I have favoured a bold approach to express the orchard of apple trees covered by their blush of pink blossom. For this kind of subject, be careful to avoid fussy rendering and over-pretty colours, or you will end up with a chocolate-box effect! When spring starts each year, out come my paints and once again I tackle this orchard. I find these candyfloss canopies quite a challenge.

I used a basic pink (white gouache and light red watercolour) or ready-mixed artists' colour as this forms a vibrant and luminous base to work on and then mixed violet, brown, yellow ochre and blues into it.

The scene is almost a glimpse of heaven, with the cottage peeping through the blossom and the dainty line of washing hanging between the trees. Sleepy sheep dozed beneath the branches but they continued to move, even in this state, so I used a couple of my children's

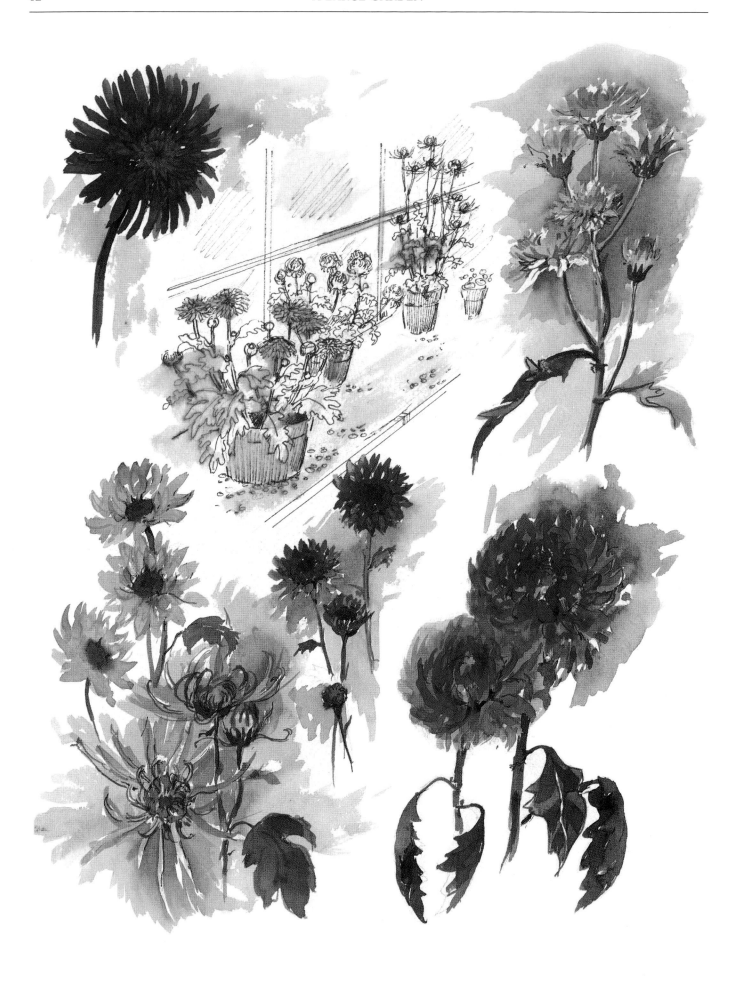

Figure 62. *A study of greenhouse chrysanthemums.*

Figures 63a and 63. *The dozing sheep in the foreground, drawn from sketchbook reference, are completely in keeping with this idyllic country scene.*

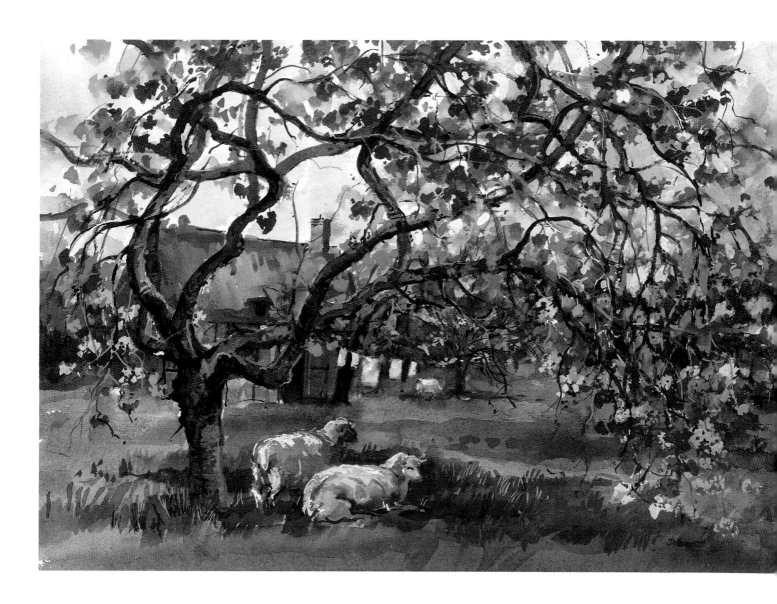

farmyard sheep for reference. These are available in sitting, lying and standing positions, and are excellent models as they can be painted at every angle and do not wander away! If you include models like this in your work, they have to nestle naturally into the surroundings and be of correct proportions. Try out a few exploratory sketches first before including them in your painting.

The tree branches are painted in yellow ochre, with blues and touches of pinks. I used ultramarine on the left hand side of the tree trunk to strengthen the outline and balance the strong pinks on the right hand side. I completed the picture by mixing a light blue and painting in the sky shapes between the branches, reinstating larger areas of sky over the blossoms where needed.

WATER GARDENS

Quiet ponds, lazy streams, formal lakes, trickling waterfalls — water adds contrast, beauty and sparkle to any garden. It is sheer magic to paint. The fascination never wanes and painters spend many hours trying to capture its illusive charm.

However, in my experience as a teacher, painting water causes more anxiety to amateurs than any other subject. Here are some important points to consider. As well as creating mirror images of surrounding colours, tones and light, water contains a considerable amount of organic matter which will affect both its colour and reflective quality. Ponds, pools and streams also have a base of dark mud or stones lurking below, creating darker tones and colours than might be visible in larger, deeper areas of water. Water will certainly reflect some light from the sky, but half close your eyes to see the real tones and colours.

Figure 64 (below). *Watercolour, gouache and ink capture this vibrant tropical atmosphere.*
Figure 65. *Swamps at Magnolia Plantation in Carolina.*

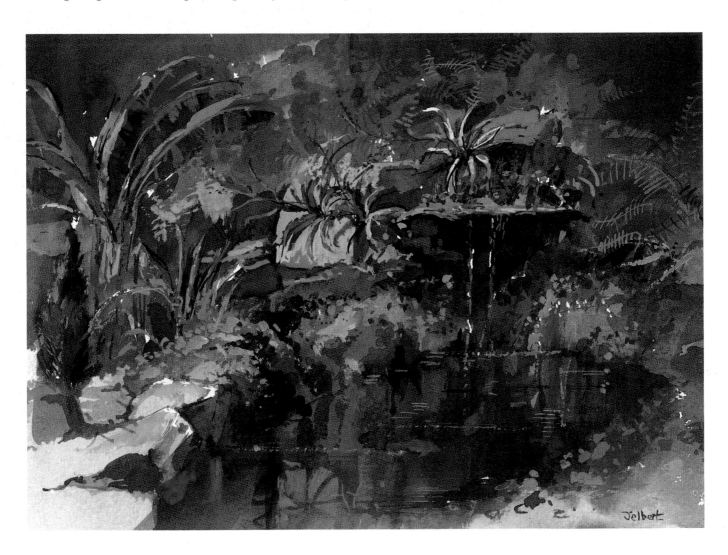

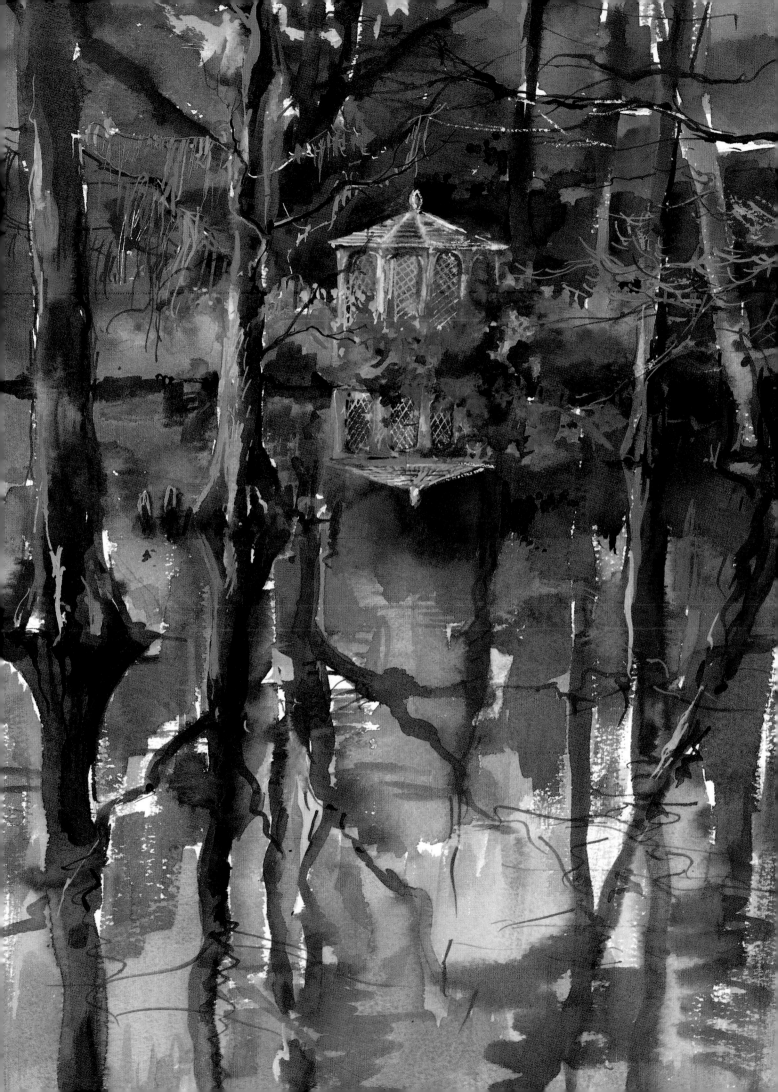

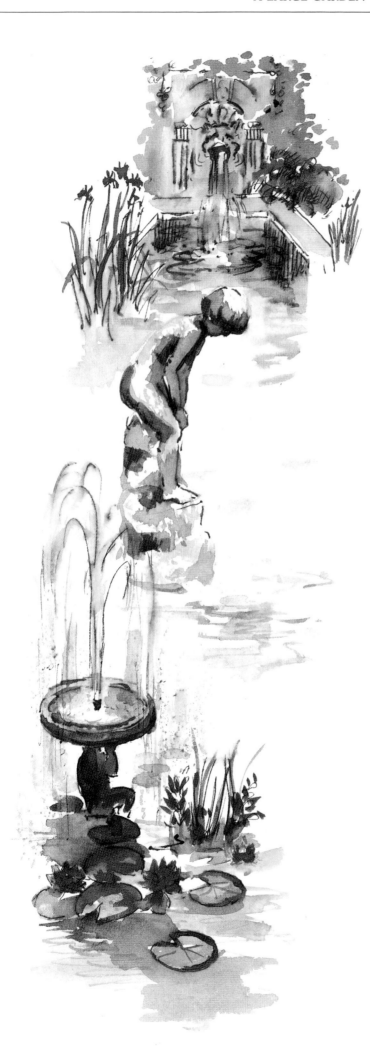

A waterfall in Trebah Gardens in Cornwall, south-west England, was the inspiration of the small watercolour on page 64. The water dribbled gently into a fishpond surrounded by lush tropical plants. I used a mixture of watercolours, gouache and touches of sharp sepia ink work.

On her return from a recent visit to America, I was intrigued by a friend's photographs of the unique and dramatic beauty of the swamps at Magnolia Plantation outside Charleston in South Carolina. I used these as inspiration for the painting on page 65.

I used the same combination of watercolours and inks on this page in the softer sketches of ornaments one frequently sees in water gardens. Decorative stone features make wonderful focal points and a cascade of glittering water can bring life and vitality to an otherwise tranquil scene. Painting water also presents the opportunity to portray plants that grow nowhere else. The beautiful waterlily is an obvious example.

PATIOS

Selecting a pleasing composition from the profusion of foliage and interest that confronted me on a friend's patio (opposite) was quite a task! Careful planning was necessary for the use of masking fluid. Having covered essential places like the flowerheads, certain buds, tendrils, leaves and other areas touched by the sunlight, I was

Figure 66. *An ornate water garden.*
Figure 67 (opposite). *A patio garden.*

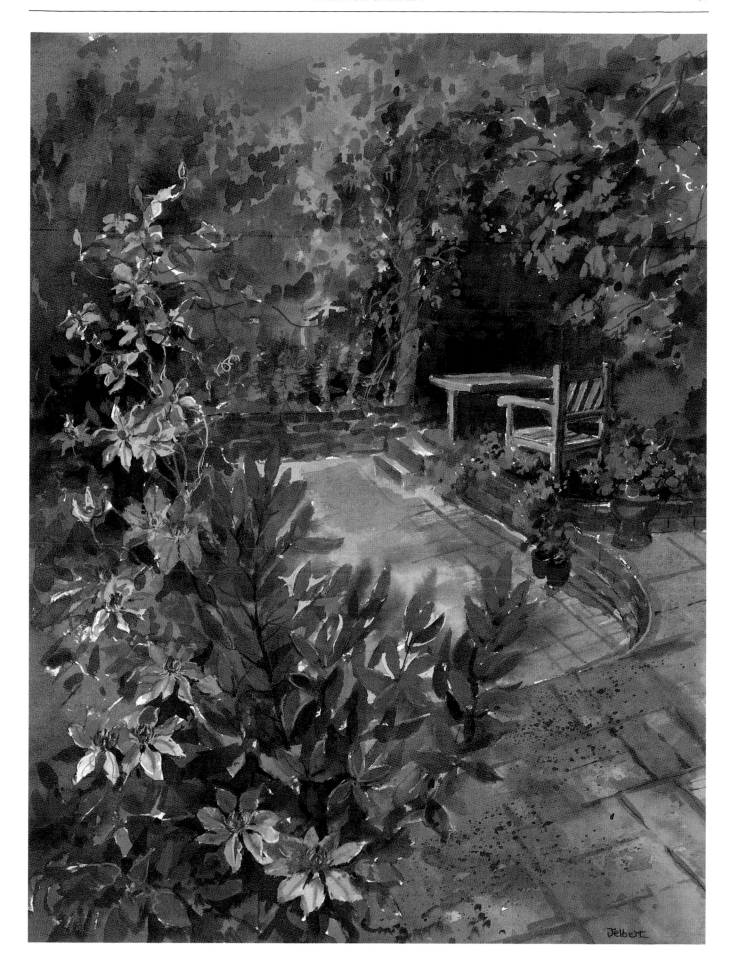

Jelbert

then free to lay in washes quickly and loosely.

The paved areas were painted briskly in soft pinks, yellow ochre and greys. I used lighter, warmer tones for the sunken area to suggest the sunny day, and to contrast with the foreground leaves which were painted in gouache over washes of olive green and terre verte. The beautiful pinks of the majestic clematis 'Nelly Moser' provided interest on the left without detracting from the focal point.

Note how the colour on the clematis is balanced and offset by the roses on the pergola and the reds of the potted geraniums. This colour link, together with the muted reds of the brickwork, creates the rhythm in this painting and leads the eye to the focal point (see page 31).

Olive green and ultramarine were used for the dark shadowed area; this accentuates the bleached, worn look of the old table and chair, touched gently by the sun.

FIGURES, PETS AND WELCOME VISITORS

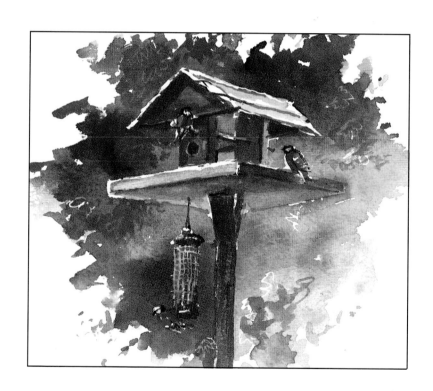

manner, resulting in a very soft look. The objects merged, giving a lively and spontaneous feel to the painting.

The girl's squatting pose guides the eye into the composition, towards the chickens and bowl. The pebbled yard was again produced using our old friend, the toothbrush, this time on a wetted surface.

GARDEN VISITORS

In Chapter 4, we saw how many of the accessories in a garden can serve as charming focal points in a painting. As an added bonus, birdtables and bird-houses attract a wide variety of beautiful birds, presenting yet another

subject. I painted the gentle doves (below), sheltering in their dovecot, on a cold December morning near Andover in Hampshire. A simple wooden birdtable could prove an equally fascinating subject (opposite).

Sketching birds presents special problems as they are constantly on the move and

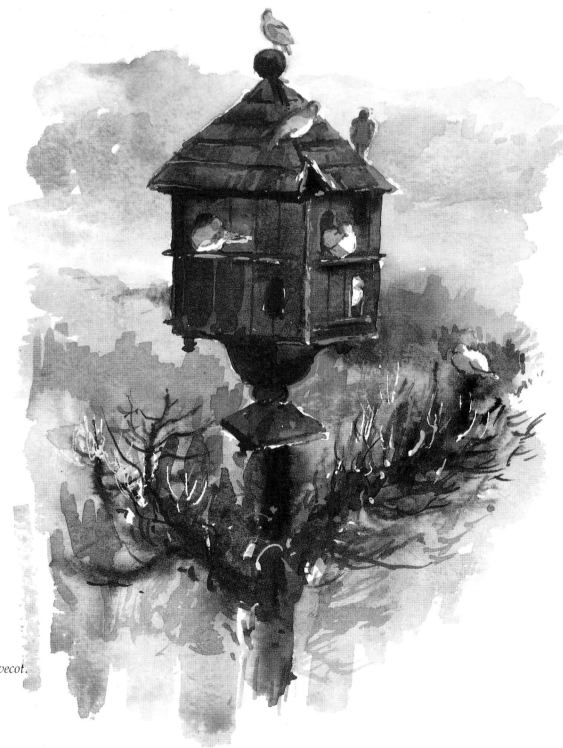

Figure 71. *A dovecot.*

frequently vanish as quickly as they come! At such times, a camera is an asset, particularly one with a zoom lens. Nevertheless, I normally try to sketch them — the dozens of unfinished studies I have made give me vital information on birds' shapes, movement and habits. I have noticed that, before long, birds tend to adopt the same posture so, even if progress is slow, your patience will be rewarded. When I am painting a group of birds, I paint the closest in most detail and simply indicate others (below).

Figures 74 and 75 on page 76 show watercolour studies and some sketches which I used as basic shapes for the painting 'Feeding the Hens' on page 73. In Figure 75, I used yellow ochre and light red watercolour for the basic straw colour, and browns, ochres and light reds for the

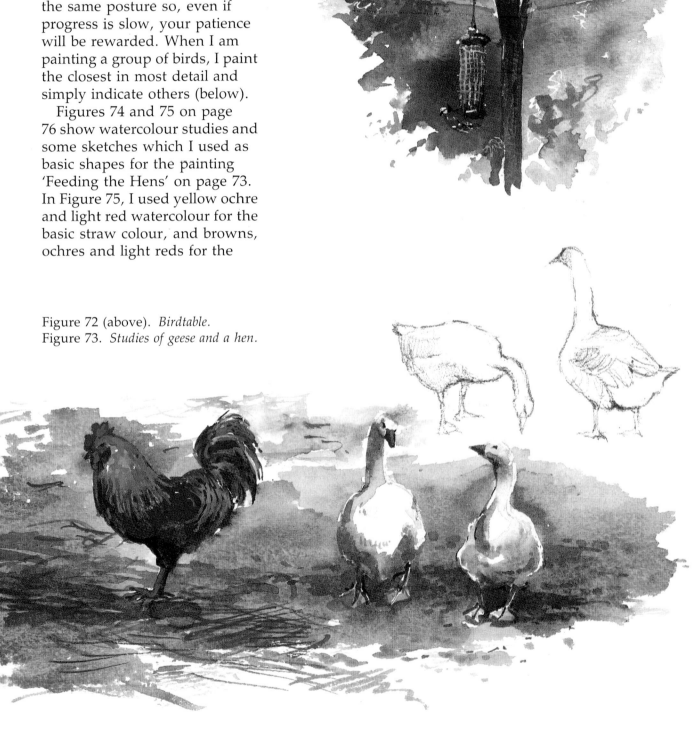

Figure 72 (above). *Birdtable.*
Figure 73. *Studies of geese and a hen.*

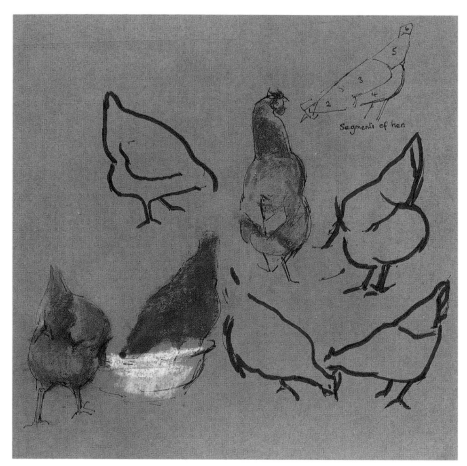

hens. Here I have divided one into six segments in order to illustrate its structure.

Geese are delightful in a rustic garden scene. I use a soft blue or violet wash to lose the stark whiteness, saving the pure white of the paper for the highlights in Figure 73 on page 75.

Opposite is my cat, 'Tina', curled up in an empty birdbath (Figure 76). I quickly sketched this unusual pose, and later did a coloured painting in my sketchbook. I also show some of my jottings, in graphite pencil, of 'Elsa' and 'Tina' (Figure 77). You need to be extremely quick in gathering information as creatures, even in deep sleep, seem to sense someone there with pencil poised!

Figures 74 and 75. *Hen studies in watercolour.*

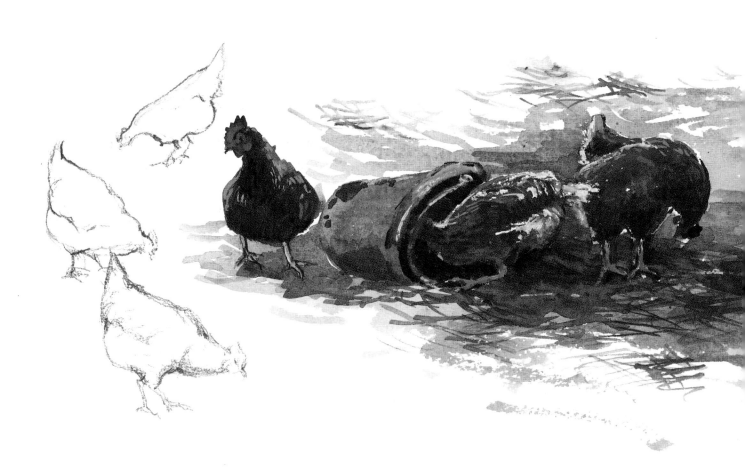

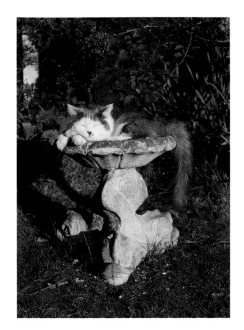

Figures 76 and 77. *Photographs and rough sketches are useful when you stumble across interesting subjects, such as those on this page.*

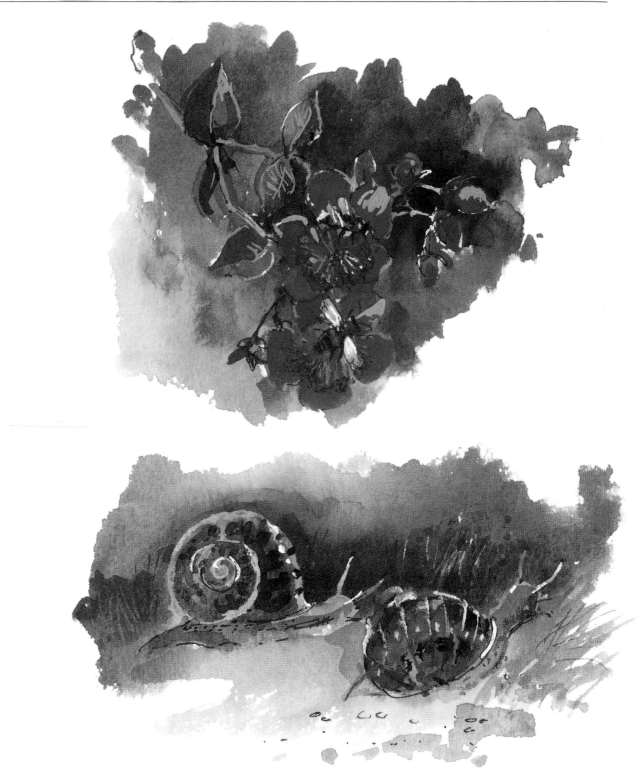

Some garden wildlife! These sometimes deserve to be a star role in a picture, as the snails and bees, or a subordinate study, as the spider's web, where the intricate design of the flowers and web obscure the tiny spider. In these studies, I have used masking fluid in the light areas, especially on the web and the snailshells. The flowers were painted in gouache, giving powerful colour and lightness: alizarin crimson and white for the dog roses, and cadmium yellow and white for the bee study. A steel-nibbed pen was used for the details.

Figure 78 *Garden inhabitants.*

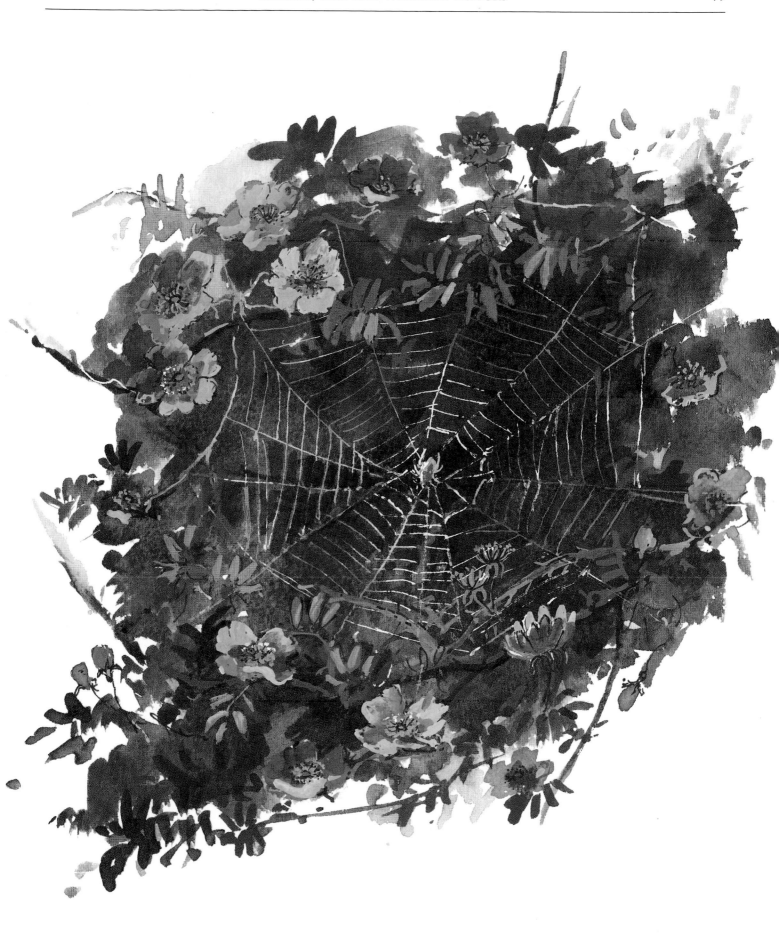

This mauve buddleia, spotted with Red Admiral butterflies, immediately enticed me to my paints! The small, individual flowers with bright yellow middles were washed in with two different strengths of colour. The farthest were diffused to give distance, and the two front spikes were painted in with more detail, using a rigger brush and cobalt violet watercolour.

The leaves of light red and terre verte green, and the background, were a similar colour but of different tones. Splashes of yellow ochre added to the wet washes connected the flowers with the distance, and with the vermilion and black butterflies.

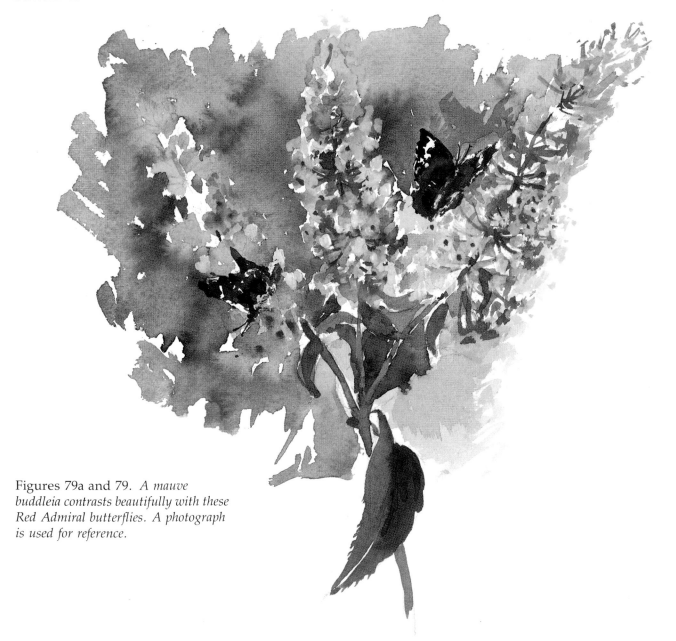

Figures 79a and 79. *A mauve buddleia contrasts beautifully with these Red Admiral butterflies. A photograph is used for reference.*

TRICKS OF THE TRADE

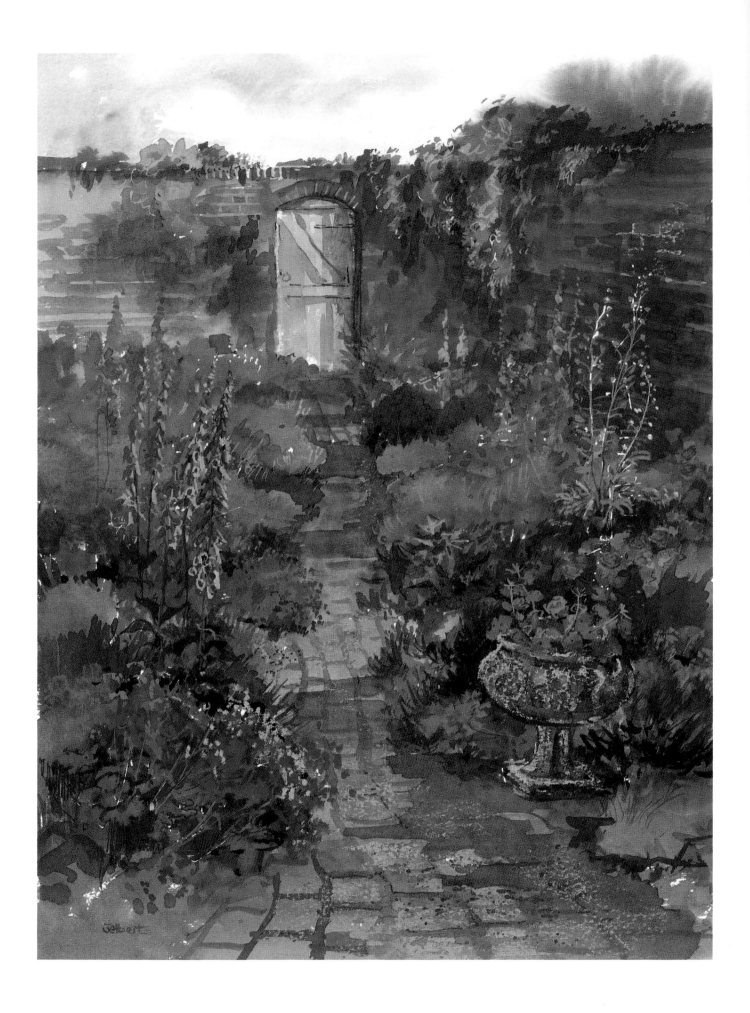

TRICKS OF THE TRADE

I am often amused at art exhibitions to see how easy it is to spot those who paint! Not content with merely gazing in admiration at a picture they like, they advance magnetically to the work, examining it or a particular part of it in microscopic detail. Then, retreating slowly, they ask, 'How on earth did he do that . . .?'

In this chapter, we will consider some of the 'tricks' used by professional painters and experienced amateurs. To the uninitiated, they seem to be able to pluck the perfect solution to any artistic problem from the air. Their technical vocabulary seems so effortless and impressive, but really it is quite simple when you know how!

Figure 80. *Many features combine to bring interest to this painting (see overleaf for stages).*

'WALLED GARDEN'

Materials

Sepia pen
Masking fluid
Watercolours (yellow ochre, cadmium red, cadmium yellow, raw umber, Vandyke brown, violet, green, light red)
Gouache (grey, white)
Oil pastels (grey, pale yellow)

Wooden door

Overleaf

(a) First I made a quick pencil sketch of the doorway. I covered it with a light green wash, and a light red wash over the brickwork area.
(b) I painted in the shaded areas of the doorway in darker green and a touch of light red, highlighting the door's structure.
(c) More details of the brickwork were painted in, and darkened with sepia pen work. I used the same technique for the edges of the door, the wood markings and the door handle.

Brickwork

(d) I drew in the outlines of the brickwork with pencil and oil pastels in grey and pale yellow.
(e) These were then washed over with light red and cadmium red, leaving the oil pastel shining through.
(f) Some of the bricks were deepened with a mixture of violet, Vandyke brown and green. I sharpened some of the bricks with a sepia pen.

Stone urn

(g–h) Pale yellow pastels were drawn in patterns, and a raw umber wash was painted over the top. Some extra pastel work can be added if more texture is needed, when the paint has dried.
(i–j) To add more depth and roughness, apply a darker colour such as Vandyke brown or violet. Still more colour can be painted in, using green against the pastel patterning.

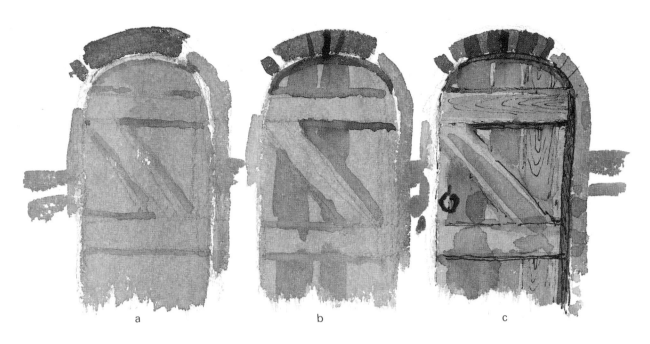

Wooden door.

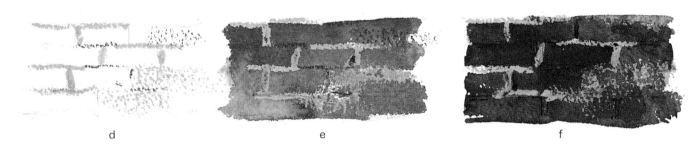

Brickwork.

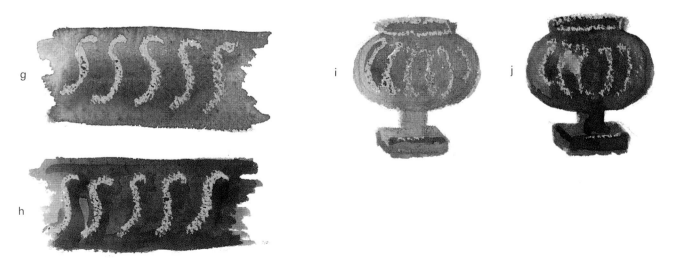

Stone urn.

Border foliage.

Paving.

Border foliage

(k) I flicked and drew on masking fluid over a quick sketch.

(l) I then applied dark and light greens and dots of red blooms, and allowed the paint to dry thoroughly before rubbing off the masking fluid.

(m) The exposed areas were washed over with cadmium yellow. With white gouache added to the yellow to give it more body. I then introduced a profusion of small bright flowers. More foliage detail was drawn in with a sepia pen.

Paving

(n) I made a rough sketch of the paving stones, and applied a wash of light red over them.

(o) When still wet, I painted in the dividing lines in green, so that they ran slightly. I splattered violet on top to give a roughened effect.

(p) I dragged a light yellow pastel over the surface of the stones, and introduced a violet and blue shadow on the right hand side.

'THE ROSE ARCH'

Gardeners and artists often differ considerably in their view of what constitutes a beautiful garden. The gardener may seek order, perfect blooms and scent, while the artist is attracted by the unusual, with softer colours, varied textures and a natural, even haphazard, atmosphere! Once again, the painting on page 89 resulted from an invitation from one of my students who, as both amateur artist and keen gardener, had a garden portraying both ideals. In this scene, there were several textural challenges.

Materials

Watercolours (alizarin crimson, light red, yellow, blue, olive green, viridian green, Vandyke brown)
Gouache (white and grey)
Coloured pencils (light red, greens, violet), cardboard, sepia ink, sponge

Arch and roses

(a) Using a coloured pencil, I first established the main features. I drew the masking fluid over the leaves, curved branches and in the folds of the rose blooms. I worked quickly into the background and leaves, using olive, touches of blue, and alizarin crimson over the roses. A weak wash depicted the arch.
(b) When the paint was dry, I rubbed off the masking fluid and painted with delicate colours over the white patterns, making them blend with their surroundings. I re-wetted the arch and darkened it, letting the colour ooze into the foliage.
(c) Alizarin crimson was dotted into the deeper folds of the roses. White gouache was mixed with viridian and olive for the lightest leaves and, since I believe that contrast is all-important, I introduced darker leaves behind them, using olive green and blue in places. The same idea was repeated in the twisting dark and light branches. I added additional flowerheads where I felt a balance was needed.

Hedges

(d) This hedge has a distinctive 'dotty' look and I immediately thought of the sponge technique. Using a puddle of olive green, I dipped the sponge in and pressed it on the paper.
(e) The hedge consists of many more greens, so I repeated the process, using yellow and laying another sponge impression over the first.
(f) For the last stage, I poured out a little sepia ink and introduced it with the trusty sponge over the previous impression, giving depth and strength.

Ivy

As we have seen, there are many ways to paint objects, and here I have demonstrated three examples of how to convey clumps of ivy. It can be difficult to get enough variation and colour difference, in order to make the whole massed effect exciting and not boring. The third method (i) is the one I used in my painting, but try all three to see which you prefer.

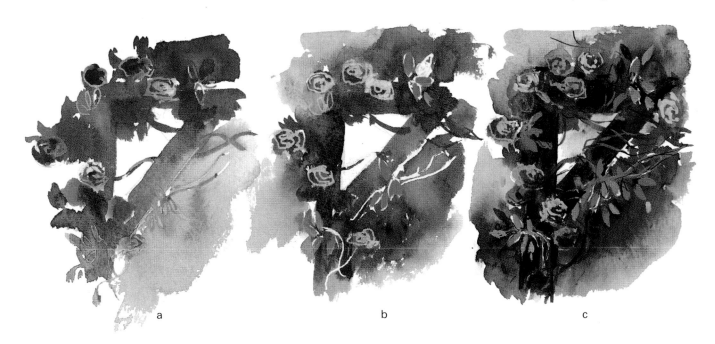

a b c

Rose arch.

Hedges.

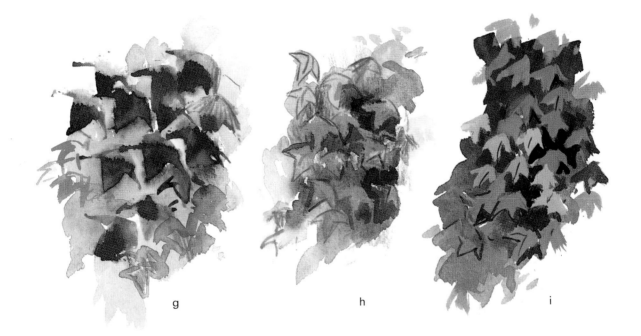

Ivy.

(g) This version uses a cardboard cut-out of an ivy leaf. Dip this in turn into a collection of greens and 'print' it at random on the picture, varying the spacing and pressure. Gentle washes can be applied over and under these shapes, blending them together with ribbons of tone and colour to soften the edges.

(h) A preliminary drawing of the ivy in coloured pencils is followed by painting in some of the leaves in solid colour, and drawing the outlines of others. Coloured pencils were used to fill in many of the leaf shapes and to emphasize the edges of others. Violet and green cross-hatching completed the background, and olive green was used between the leaves to bring them forward.

(i) After the drawing is completed, paint green into the background to help highlight the leaf mass. Lighten some leaves with white gouache and green. Finally use a rigger brush to outline some leaves and add the vein markings.

Fountain

(j) My first step was to place in the stone fountain and the delicate spraying water spout. I used masking fluid on the water, round the top of the stonework and on the background grass. After drying, I worked in grey gouache and a watery wash of light green. Once this had dried, I added sepia ink on the fountain shape, giving it a 'drawing' look.

(k) I darkened the background considerably with blue, violet and green. I was trying to create the feeling of tumbling water, and it began to take shape when I rubbed off the masking fluid and exposed the tender spouts of water. The broken effects of light were an ideal partner for the foliage masses in the background.

(l) A deep grey, using olive green and violet, livened up the decoration on the fountain and gave it form. I then added a light blue wash over the water area, leaving glimpses of the white exposed paper underneath.

Rose arch: the finished painting.

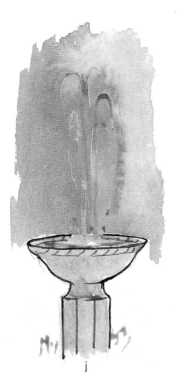
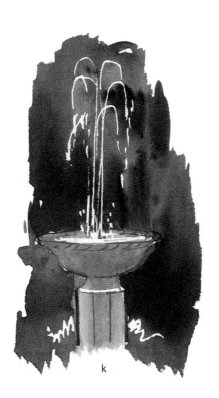
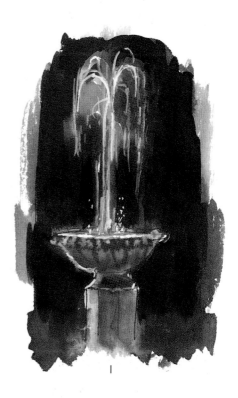

j　　　　　k　　　　　l

Fountain.

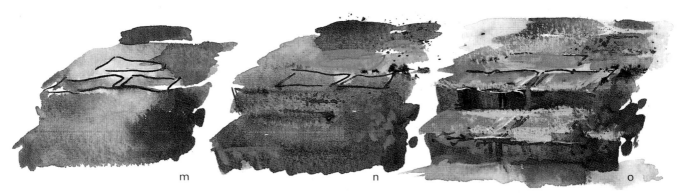

m　　　　　n　　　　　o

Pathway.

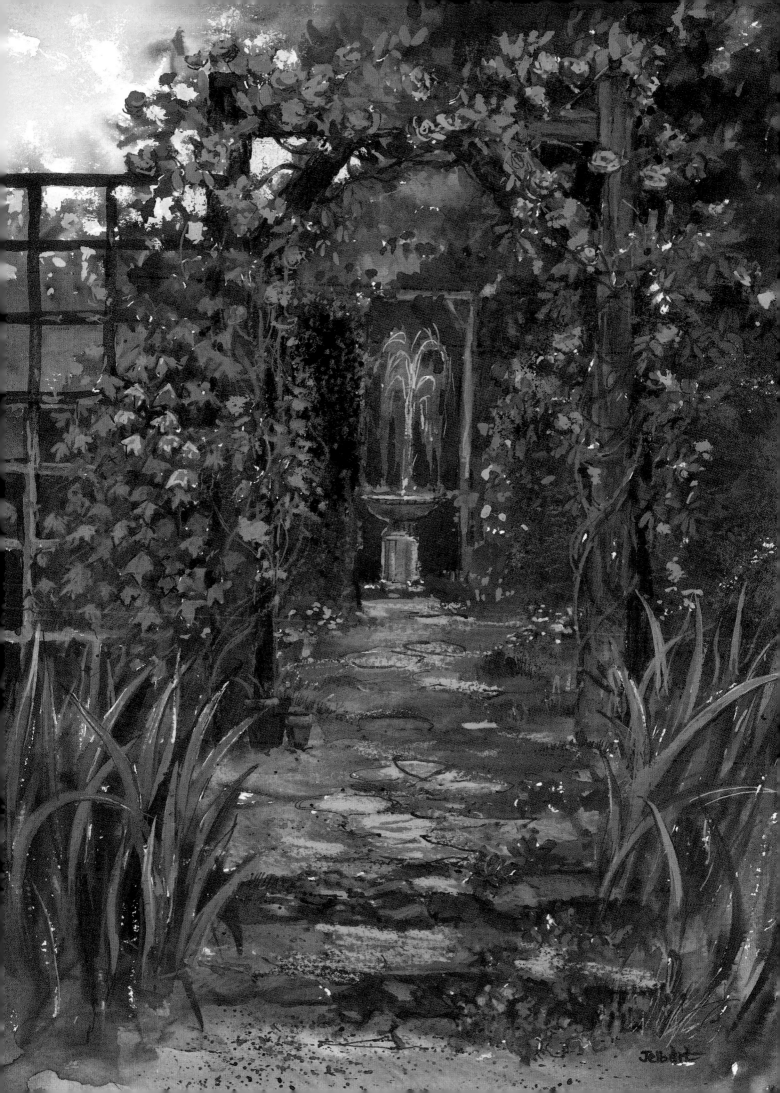

Pathway

The addition of a pathway can lead the eye gently into and around a garden setting. Constructed wisely, in terms of colour and texture, it will nestle comfortably into its surroundings and will never leap from the painting like a writhing snake!

Here, I used a crazy paving pattern, incorporating most of the colours that I have used elsewhere in the painting. This 'settles' the path and unifies the whole painting.

(m) Having worked in a watercolour underpainting of yellow ochre and Vandyke brown, I quickly added the impression of foliage on the right in yellow and viridian. Once I had drawn in the steps and slabs, I slowly began to build up textures by using pen and ink for their outlines.

(n) In order to create the effect of the different surfaces, I varied the colours of the stonework in greys, using gouache mixed with violet, yellow, and greens. The darker stones were painted using brown, and a splattering of ink completed the effect of a roughened and worn path. The bottom step was defined in a darker wash, using brown, light red and green.

(o) To finish, I used opaque paint on the top slabs and second step. I continued the gouache into the foliage, using white, yellow and green in a dabbing manner. This was then accentuated with darker greens. Finally, the steps were further dramatized by adding a layer of broken pale yellow and grey pastel worked on top of the dried watercolours.

'THE COTTAGE DOORWAY'

I was so smitten by the natural beauty of the Cornish cottage on page 92 that I immediately set to work to capture its green door and surrounding collections of textures. I have highlighted four of its features in this painting: the rough stonework, the crusty buttercup-coloured lichen, the rustic wooden barrel and the pebbled pathway.

You may find it easier initially to copy my examples and then to have a go yourself. There are many ways of achieving patterned surfaces and textures; the more you experiment the more alternatives you will discover. Be careful to chronicle your experiments and successes in your sketchbook, otherwise they may be lost forever.

Materials

Coloured pencils (brown, green, light red)
Drawing pen
Masking fluid
Watercolours (permanent yellow, light red, Vandyke brown, yellow ochre, olive green, viridian)
Gouache (white, grey)
Ox gall (see page 14)
Oil pastels (pale yellow, grey, light red, light green)

Stonework

Initially, I mixed plenty of yellow ochre, grey and Vandyke brown in separate compartments of my palette.

(a) With a brown pencil, I drew the layout of the stonework, then coloured in the area of cement rendering with the grey pastel, leaving some of the paper untouched. Pale yellow was then 'pulled' over the roughened surface of some of the stones.

(b) The prepared yellow ochre was applied to the whole surface, and the grey and brown dropped in 'wet-into-wet', giving a softened and random look. Note the lovely water-resistant effects of the oil pastels. After the surface had dried, I work in a little more pastel, including light red, outlining and accentuating some of the stone; this can also be done using coloured pencils. I like the unexpected effects of cement between the stones, and the way it forms lighter layers on top of the surrounding areas.

(c) Finally, I dragged grey pastel over the cement rendering between the stones, to unite the work and give it a matured effect.

Lichen

The yellow lichen brings out the richness of the wall. The warm dashes of colour balance well with the strong brightness of the foxgloves.

(d) The rusty nail was drawn in amidst the stonework. Masking fluid was then applied to the edges of the stones, the nail and string, and allowed to dry. Olive green, light red and ochre were washed over the stone areas, leaving the cement bands free of colour.

(e) Light red watercolour was painted over the nail and into the surrounding area, and allowed to run slightly. I applied a layer of grey and dropped ox gall into it for the foundation of the lichen. The cement was painted in, using grey gouache and a little light red. The masking fluid was then removed.

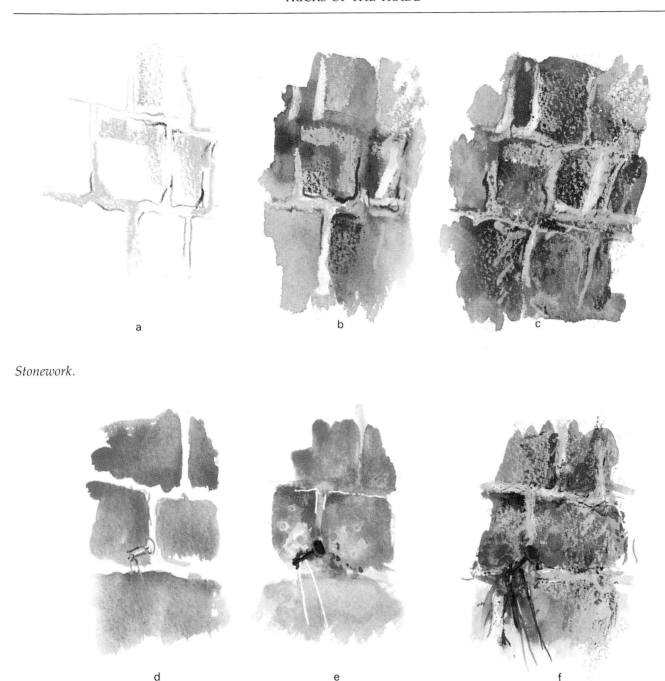

a b c

Stonework.

d e f

Lichen.

(f) The details of the nail and string were painted in with a rigger brush. I dragged pale yellow pastel over the stones, again hoping for a roughened look. Vandyke brown was used in tiny accents on some of the stone edges. The mottled ox gall area was painted over with a thick yellow, letting it run into and over the stonework but allowing

the natural patterns already there to form the basic shapes of the lichen. I then gently outlined some of the edges with pencil, giving a crusty, natural look.

Wooden barrel

(g) This lovely curved man made prop, overflowing with tufty grasses, was an excellent foil for

the ridged steps. I quickly sketched in the main shapes and put masking fluid on the areas needing highlighting — the grasses, top of the barrel and edges of the steps. I washed yellow ochre all over the picture surface and, while it was still wet, dropped in olive green and viridian to indicate the grasses and Vandyke brown for the

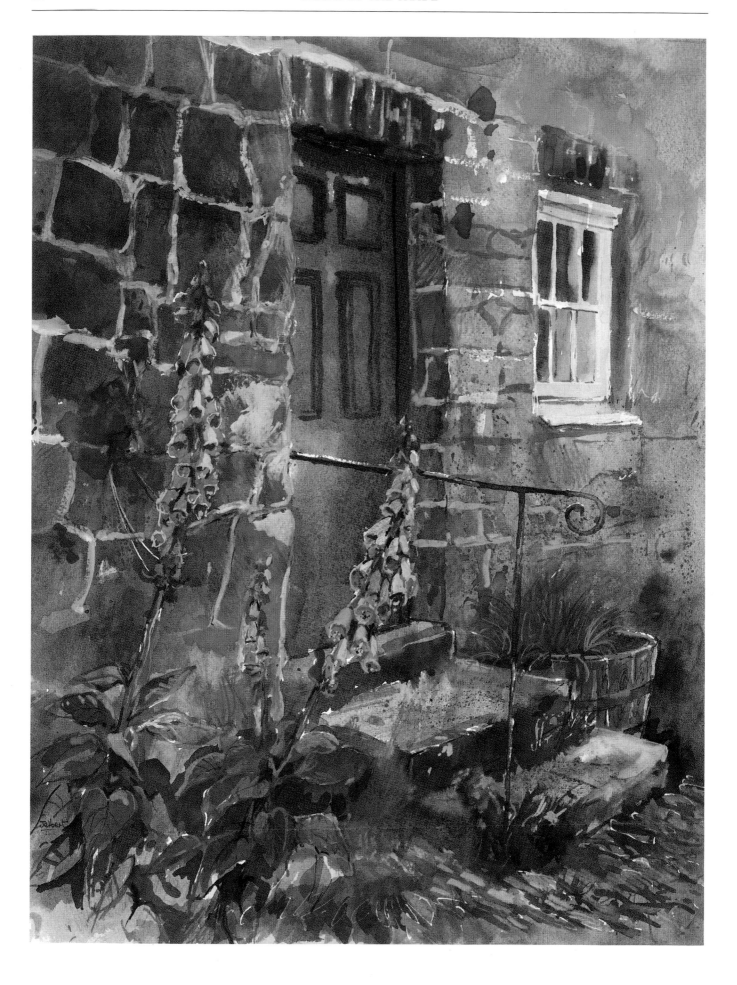

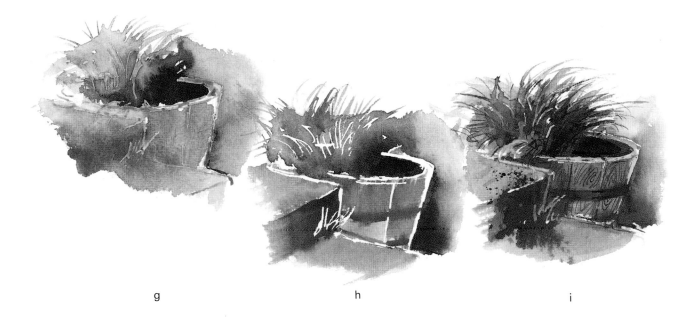

g h i

Wooden barrel.

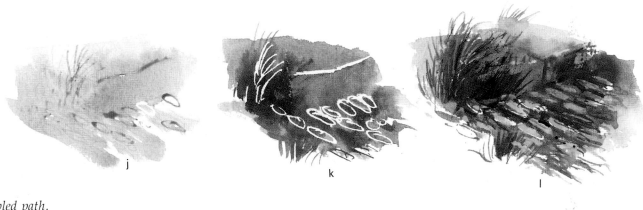

j k l

Pebbled path.

earth. A splash of light red was added to the top step.

(h) Over the light red watercolour, I painted a little brown to emphasize the sunlit features adjacent to it. When it was completely dry, I rubbed off the masking fluid. I applied more greens behind the barrel, giving it more contrast, then placed a dash of grey on the second step, so that cooler areas offset the warmer surroundings.

Figure 82. *Cottage doorway: the finished painting.*

A mixture of brown and green was used for the metal barrel rings. Ochre was worked into the white patterns left by the masking fluid.

(i) The grasses were warmed with ochre, and the steps were 'splattered' gently with browns to break up their smoothness. The woodgrain effect was painted in carefully in brown, using a rigger brush. This can easily be drawn in with a brown coloured pencil when all the watercolour underneath has dried.

Pebbled path

This unusual cobbled path inspired me with its soft greys, browns and greens moulded into rounded pebbles, fitting edgeways to form a beautiful patterned foreground for my picture.

(j) Masking fluid was drawn onto the rounded outlines of the pebbles, the step and the grasses. A little ochre with a whisper of grey was painted over it.

(k) Whilst still damp, greens were coaxed into the grasses,

grey into the step and light red into the pebbles, then allowed to dry.

(l) After the masking fluid had been lifted, the white parts were painted with a weak wash of grey. I outlined some of the pebble shapes with Vandyke brown, and drew the forms of others at random. The grasses were brightened with glimpses of light green pastel.

STEP-BY-STEP

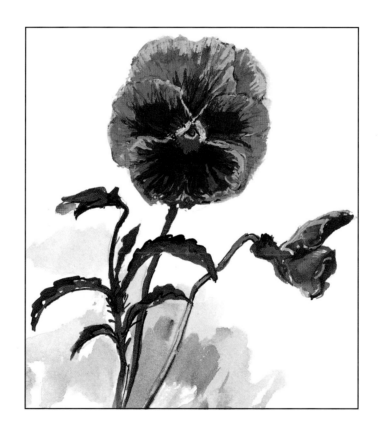

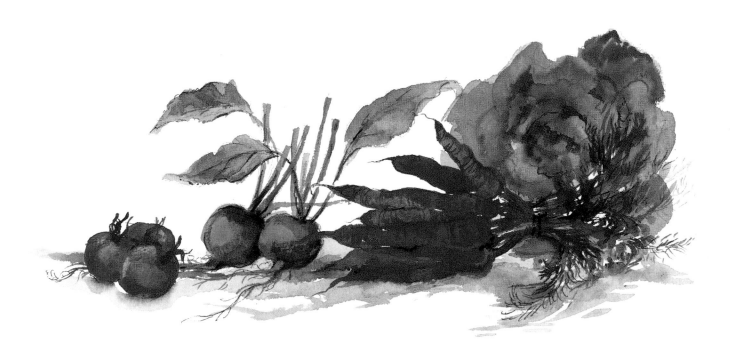

\mathcal{S}TEP-BY-\mathcal{S}TEP

'CARROTS'

The textures and colours of newly picked fruit and vegetables from the garden make a wonderful still-life subject. I have chosen a bunch of carrots as the first subject in this chapter because of the contrasting colours and the interesting shapes. They could be used in a painting with a variety of other vegetables, or just painted as they are. I picked them fresh from my garden thinking they would be ideal for a beginner's exercise, and placed them randomly on the kitchen table ready for work!

Once again, several steps were carried out in order to achieve the depth of colour and tone in the finished painting (see overleaf for stages).

Materials

Masking fluid
Watercolours (ultramarine blue, yellow ochre, viridian, olive green, vermilion, light red)

(a) I carefully drew in the simple carrot shapes, overlapping them in a natural manner. I applied the masking fluid to the delicate foliage areas and stalks, and let it dry.

(b) I filled in the background colour, varying the yellow ochre tones with tinges of blue. Whilst still wet, the leaves were placed in with a blue and yellow mixture. The carrots were blended with yellow and vermilion, with light red for the dark-shaded carrot.

(c) For the darker foliage, a blue-green wash was placed over the wet lighter ones, allowing them to mix into each other. Yellow ochre and light red with a sprinkle of blue were painted over the orange carrots, giving them form and a feeling of texture. The masking fluid was then lifted.

(d) At this point, I added blue to emphasize the shadows under the vegetables and around the dainty foliage. The 'naked' white paper left by the removal of the masking fluid was briskly washed over with light green. It is a personal choice how detailed you like the painting to become; more work can easily be included, but I prefer this exercise to be as simple as possible.

Finally, I added deeper shadows to the carrots, slightly 'pitting' the surface to give extra interest. Yellow ochre was added in places to blend the carrots into their surroundings.

Figure 83. *A selection of fresh vegetables makes a wonderful still life (see overleaf for stages).*

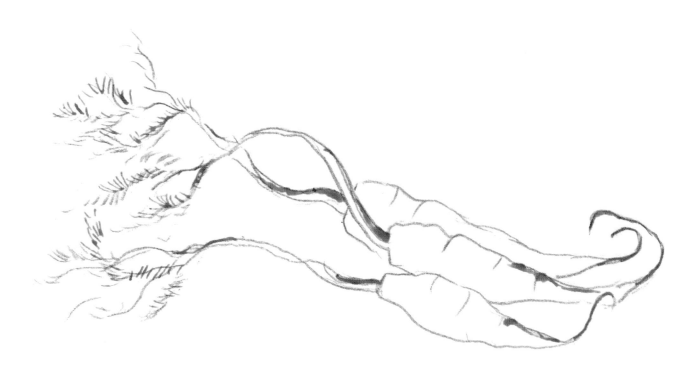

Stage 1 (a)

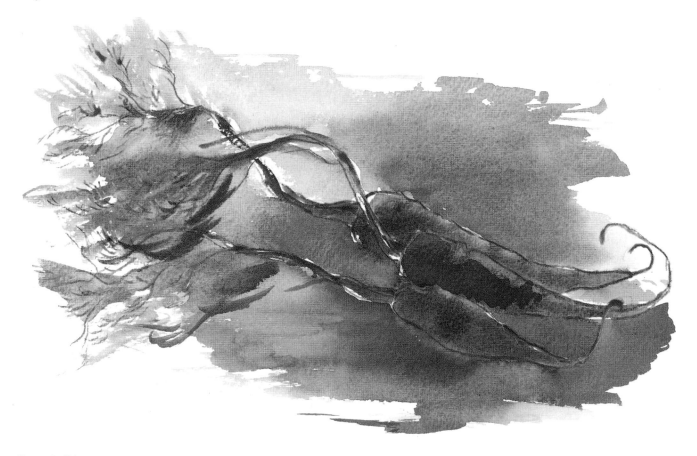

Stage 2 (b)

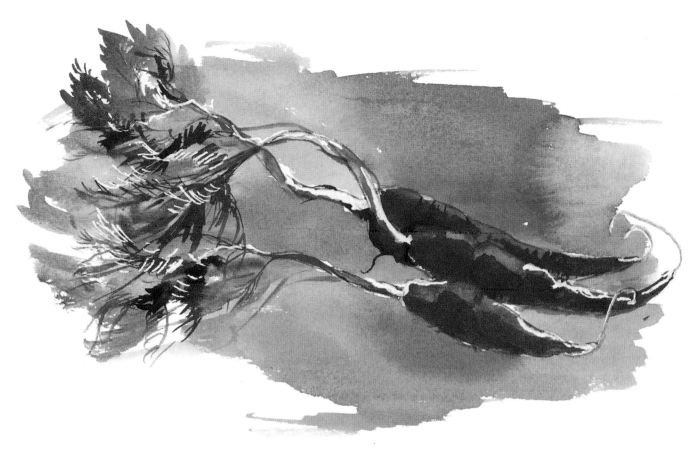

Stage 3 (c)

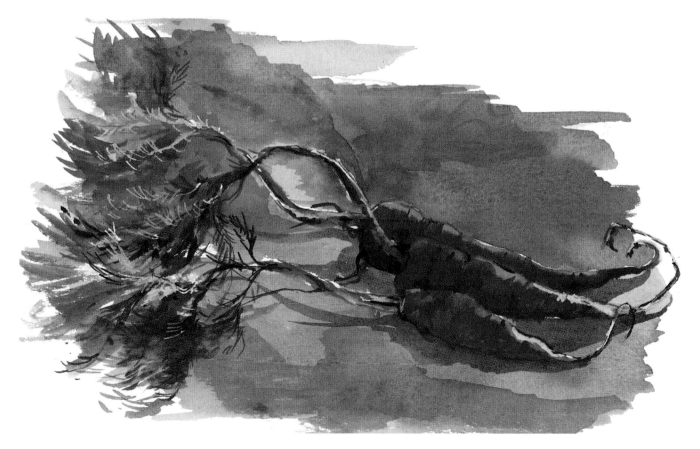

Stage 4 (d): the finished painting.

PANSIES

There are several ways of painting flowers: arranging them in a vase, fixing them in 'oasis', or painting them *in situ* in a garden. Here I decided to pick a single stem and bud, and laid it on my watercolour paper. The final picture was painted sitting cross-legged in front of a garden urn, which was brimming with these cheeky little faces!

Materials

Masking fluid
Watercolours (alizarin crimson or violet, yellow, cobalt blue)
White gouache

(a) After drawing in the outline of the pansies, I added masking fluid round the petals and centre, in the bud and along the leaf edges.
(b) I began by using a cobalt blue and a violet wash across the background, then painted green on the leaves and stalk, and yellow into the flower face and buds.
(c) While the violet (cobalt blue and alizarin crimson, or ready-mixed violet) was still wet, I added orange washes to flow into the surrounding colours. This gave the petals depth and interest. Alizarin crimson was painted into the bud and round the rich central parts of the pansy. When the paint was dry, the masking fluid was lifted.
(d) There is quite a difference between stages (c) and (d). What appealed to me most was the striking contrast, alongside the closeness of tones and colours, within this small, flat-headed flower. I included quite a lot of detail by mixing white gouache with the basic colours to portray the delicate pastel markings.

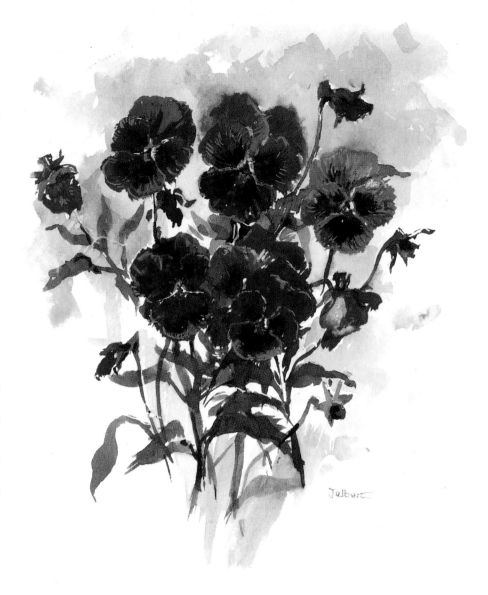

The main point to remember when arranging flowers is to vary their positions slightly to give contrasts in shape and colour. A few buds and seed heads will soften the edges, add variety and, above all, help achieve a natural look.

Figure 84a–d (opposite). *The stages in drawing pansies, starting with a single stem and bud.*
Figure 84. *The finished painting.*

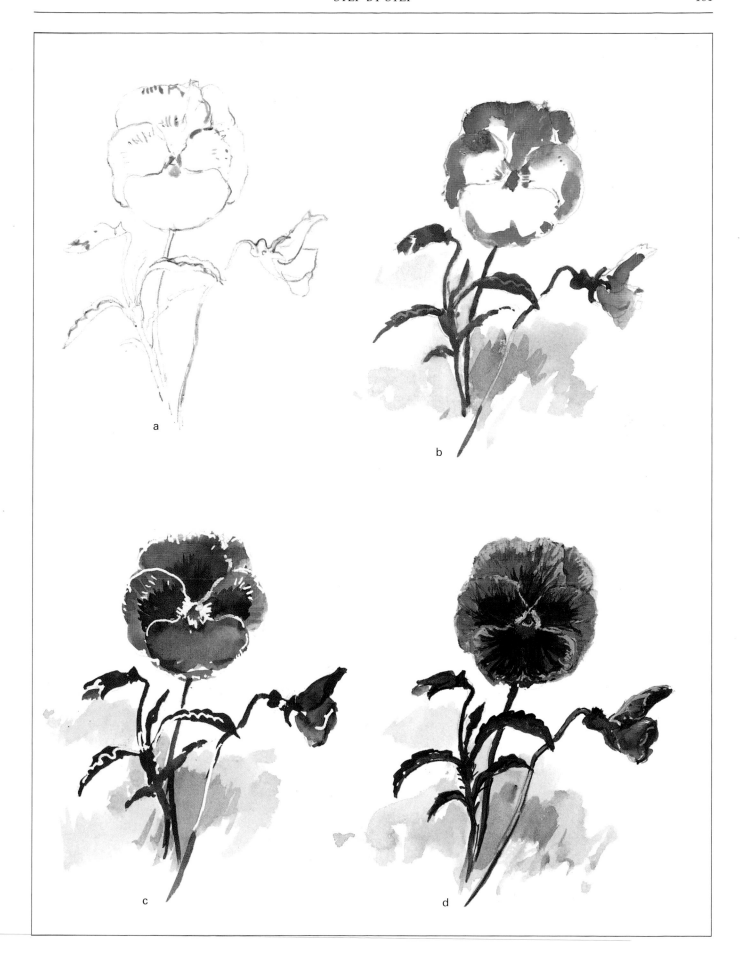

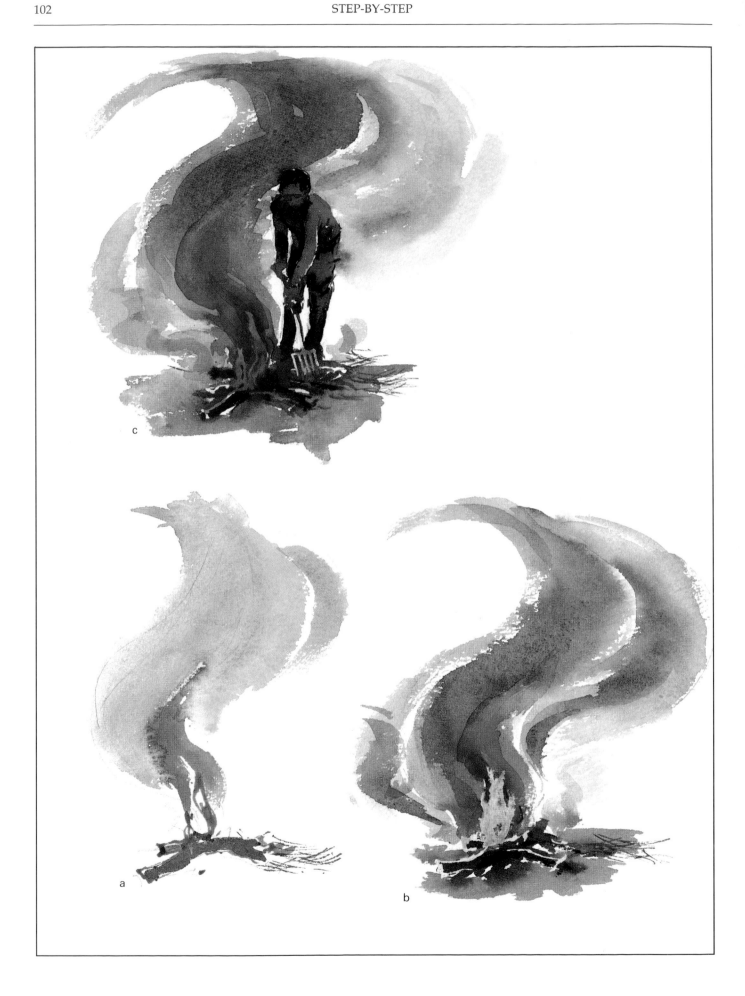

'BONFIRE'

I adore the crisp afternoons and the fascinating crackle of a bonfire as golden autumn slowly edges out summer. The thick ribbons of swirling grey and white smoke are fascinating to try and capture in a painting!

Materials

Masking fluid
Watercolours (Paynes grey, cerulean blue, raw umber)
Artists' colours (yellow, yellow ochre, vermilion)

(a) Sometimes, when the subject matter is complicated, it is best to sketch it and then go away and digest the impression. When your ideas have formulated in your own personal way, then you can make an attempt to portray the scene.

I vaguely drew in the smoke and some logs. To enhance the lighter areas, I added masking fluid to the burning wood and flame base. I used a wide brush to achieve the soft, semi-abstract blending of smoke and flames, whilst keeping the colours clear and direct.

(b) With my large brush loaded with Paynes grey, I intensified the design and tone of the smoke area. I introduced the vivid vermilion artists' colour into the yellow ochre, increasing the warmth and luminosity of the fire's heart. Raw umber was used in varying strengths for the wood and twigs. Blue, grey and raw umber were used for the various tones, colours and shadows on the ground, with a wash of yellow ochre adding warmth and light. These colours certainly added depth and vibrance to my painting. I rubbed off the masking fluid in readiness for the highlights from the flames.

(c) I introduced a figure at this stage, as I felt it added drama and substance to the composition. The remaining white exposed areas on either side of the bonfire were covered with a thin wash of yellow. Finally, I used a splattering of raw umber, light red and grey to create texture in the foreground.

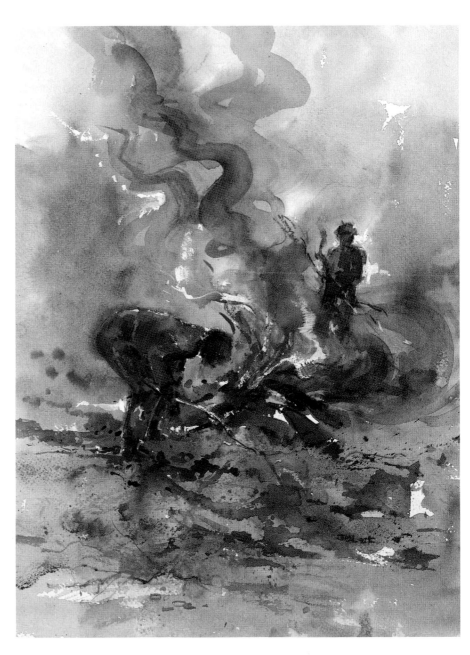

Figure 85a–c (opposite). *A complex subject such as this bonfire is tackled in several stages.*

Figure 85 (below). *The inclusion of figures adds interest to this bonfire scene.*

'AN AMERICAN GARDEN'

Aspiring artists are well advised to study reproductions in books and to visit galleries, to compare how different artists have tackled the complicated task of flower and foliage interpretation. The theories of perspective, colour and composition have been a lifetime's study for some artists, while others have ignored all 'rules' and have produced wonderful pictures. If you try this exercise, you will become aware of the massed areas of plants and how they nestle in contrast and harmony with one another, plus the problem of dealing with buildings partly covered by plants.

Materials

Graphite pencil
Sepia drawing pen
Masking fluid
Watercolours (alizarin crimson, vermilion, viridian green, olive green, light red, cobalt blue, yellow)

(a) I achieved the crisp detail with a graphite pencil. The angles and position of the plants were carefully considered. Masking fluid was placed on the outlines of the flowers, some of the foliage and the edges of the beanpoles and gables.
(b) I quickly washed in the cobalt blue sky and, while it was still wet, dropped in a little olive green for the distant tree. The grey wooden house (cobalt blue and light red) was painted in, varying the colour slightly. An assortment of cool colour (using blue and viridian) and warm greens (using yellows, light and vermilion reds, and orange) was blended and arranged over the flowerbeds. These have to be in

an ordered 'rhythm', contrasting the darker accents against the lighter ones and keeping the separate plants as impressions.
(c) I deliberately allowed the luminous pink of the phlox (this could be in artists' colours) to be drawn into the surrounding greens. Vermilion and other bright colours can be splashed into the greens, creating the image of a colourful display. The masking fluid was rubbed off, revealing a rather complicated

light pattern which was immediately covered in light greens, bright yellows and pinks. The whole scene was completed by finishing the house details in sepia ink, and by drawing more specific characteristics into the profusion of greenery and flowerheads.

Figure 86 (a) (above). *Detail is achieved using graphite pencil and masking fluid.* (b) (opposite). *Colour is added.* (c) (overleaf). *The finished painting.*

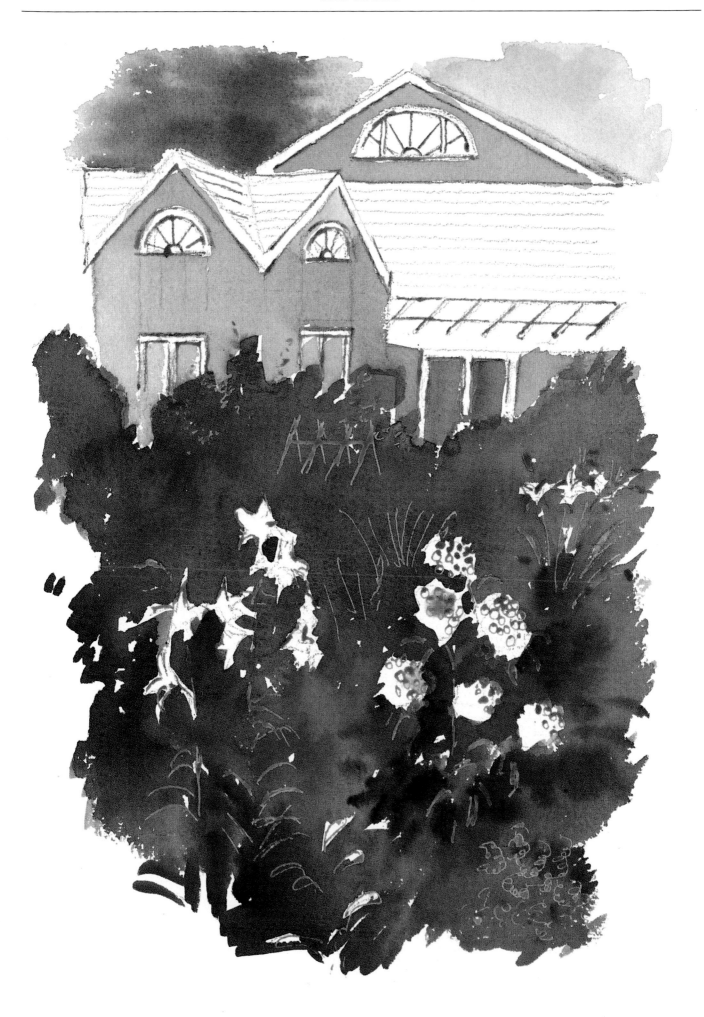

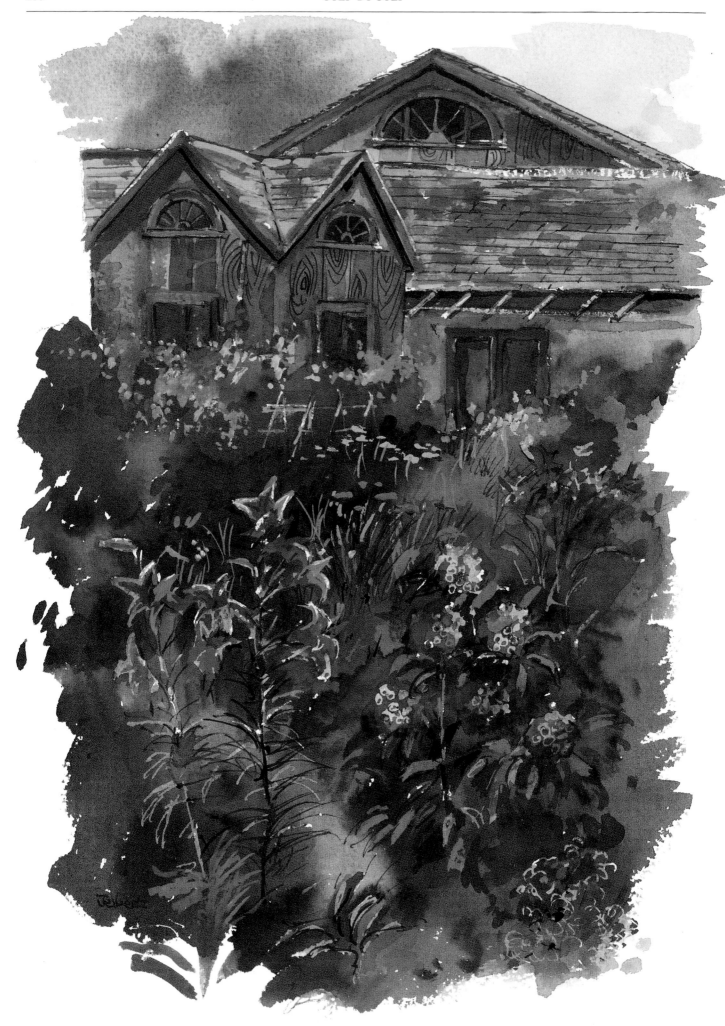

INDIVIDUAL GARDENS

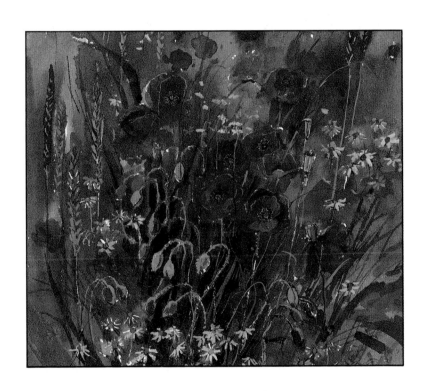

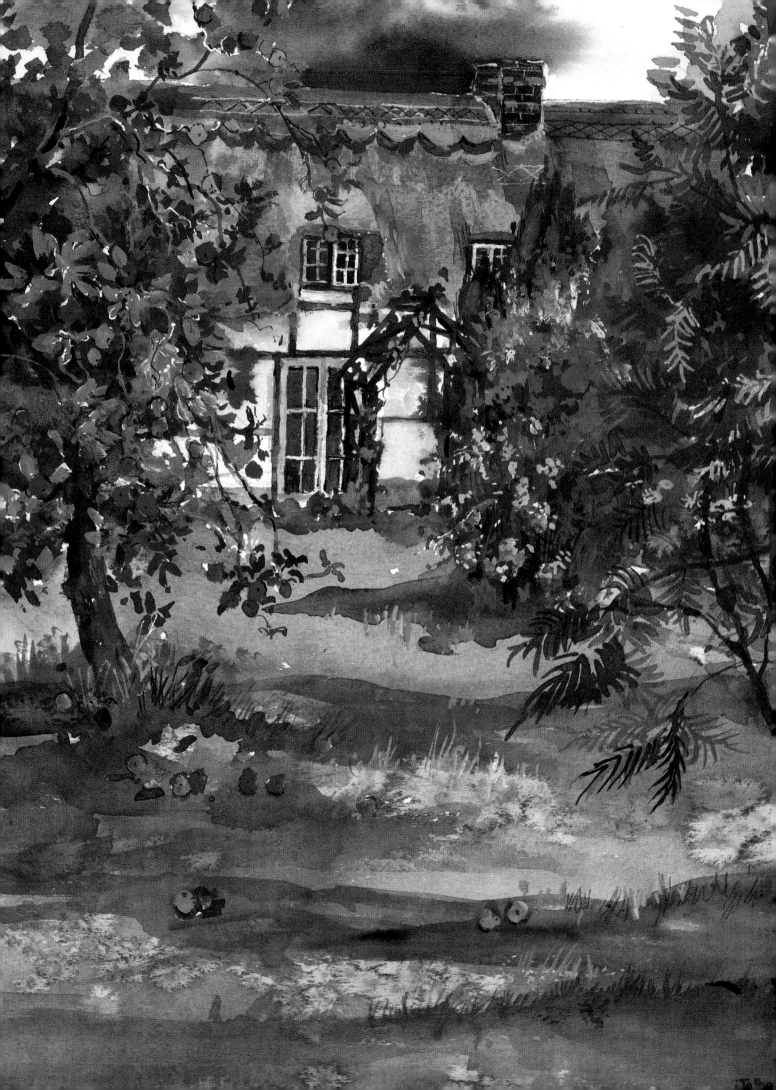

INDIVIDUAL GARDENS

COTTAGE GARDEN

By the 1880s the cottage garden was proclaimed by the horticultural writer, William Robinson, to be an alternative to the grander Victorian garden. Here plants that had fallen from popularity, such as wallflowers, daisies, pinks and hollyhocks, were preserved, many grown for their practical and medicinal uses. Artists such as Birkett Foster, Theresa Stannard, Caroline Sharp and Arthur Claude Strachen presented a sentimental image of cottage gardens covered with climbing honeysuckle and mounds of pansies and nasturtiums. In reality, times were hard, with many mouths to feed.

In easier, more affluent times, modern painters still seek out cottage gardens as subject matter, perhaps as a reassuring contrast to our sophisticated geometric and concrete world.

Figure 87. *The view from my studio window.*

The view from my studio window towards our cottage shows that I was seduced by the same ideal (see opposite)! The old apple tree provides strength and interest on the left and the splash of yellow laurel and pink phlox balances beautifully on the right. The feathery 'Tree of Heaven' was painted in gouache with a rigger brush, taking care to emphasize its texture and contrasting tone in relationship to both background and foreground.

The body of the thatch was painted in yellow ochre, light red and a touch of olive green. The cross-hatched details were drawn later with sepia ink and finally highlighted with white and Naples yellow gouache. Masking fluid was used for the white windows and French doors. In the foreground, I sprinkled a small quantity of sea-salt on the washes to get that mottled look. The shape of the rose arch gave the necessary extra depth and was an appropriate feature to link the cottage to the garden.

On holiday in Cornwall, I sketched the entrancing slate-roofed cottages overleaf with their rich abundance of Japanese anemones butting up to the stone wall. In order to portray the delicate white flowers with their lovely ivy-shaped leaves, a dark background was necessary for the blooms. I used mauve for the main part, gently introducing a combined paler version of the leaves and background colour. I then outlined some of the pastel petals with a pink aquarelle pencil, giving them a warm finish.

For a painter, there is no hierarchy in the world of plants. All have their personal appeal or beauty, as I hope is evident from the painting of poppies (see page 112) and the drawing of wildflowers. What an exciting few hours I had recording the shapes and textures of the campions, field scabious, vetch and Old Man's Beard that I discovered in a neglected part of the garden (page 111). Confronted with such abundance, always remember the value of elimination!

Too much in too little space
makes for a confused picture,
however beautifully it is
painted. Have the courage to
leave things out, and work
scenes out well beforehand in
your sketchbook.

Figure 88. *Colourful anemones make a*
good contrast with slate-roofed cottages
and grey stone walls.

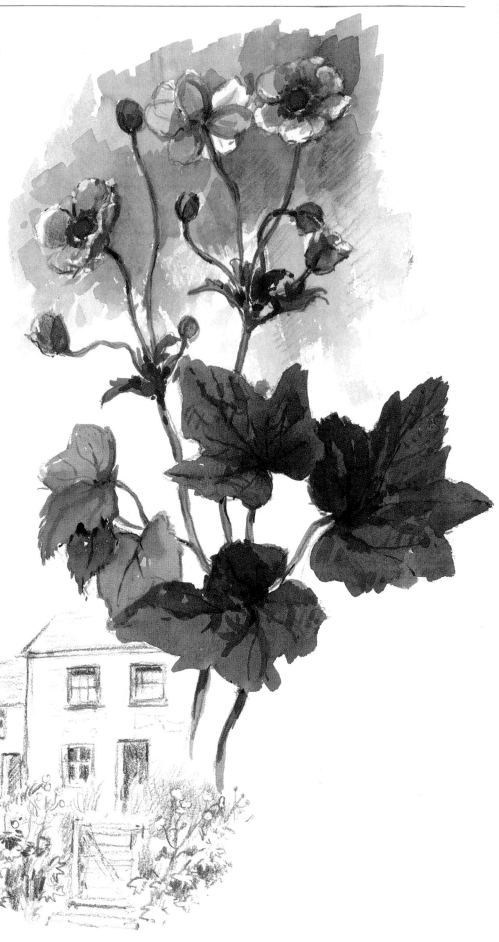

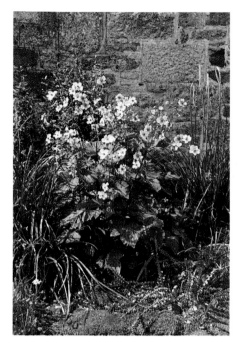

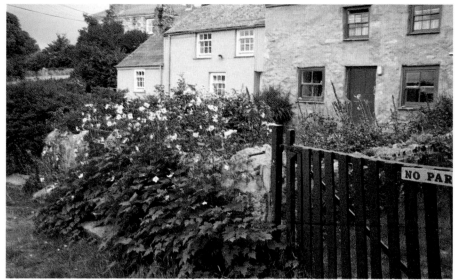

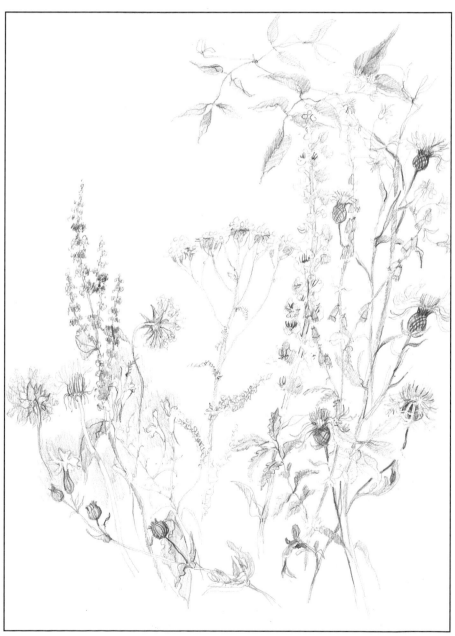

Figures 88 (a) and (b)
(above). *Photographs are used for
reference.*
Figure 89. *A sketch of campions, field
scabious, vetch and Old Man's Beard
found in a neglected corner of the garden.*

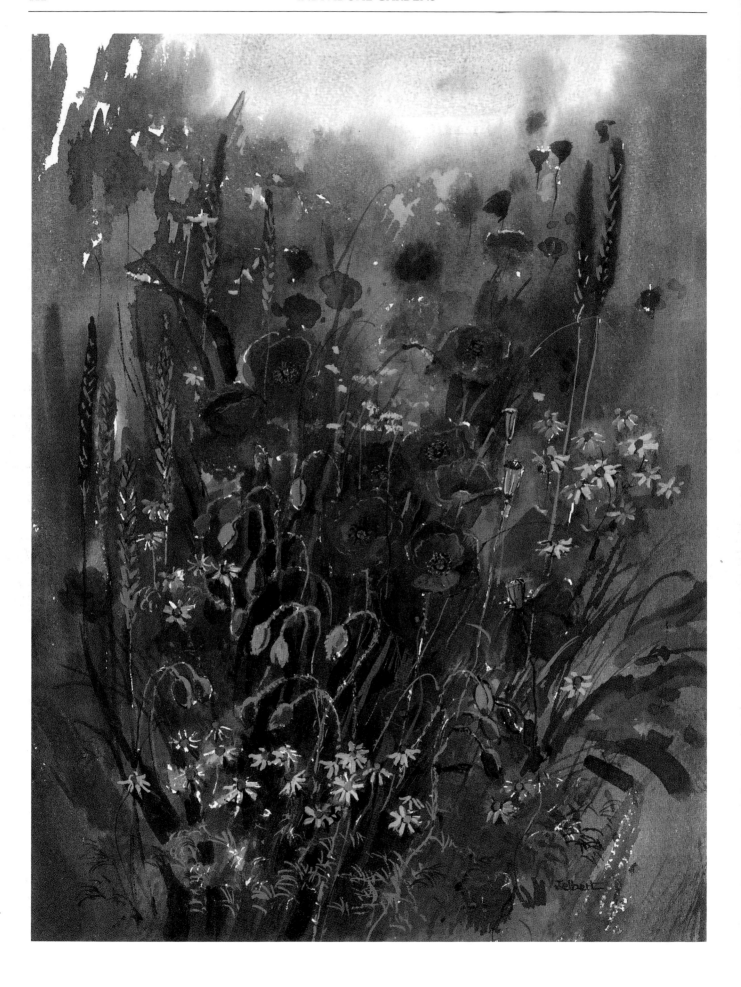

ALLOTMENTS

The allotment offers an amazing study of life 'in the raw', with a wide contrast of subjects and mood: beanpoles laden with summer's crop; droplets of dew, sparkling like a necklace of diamonds, strung from a wire fence in the early morning sun; or grey puddles on a winter's day.

The curling smoke first attracted my attention to these allotments near Romsey in Hampshire. Then I saw the patchwork effect of colour and shapes, the jumble of huts and chicken wire, and vegetables at various stages of growth, and I was hooked! As a project, I had set my students the task of choosing a place and then painting it over four seasons. I chose this allotment for my demonstration and here are the autumn and winter scenes.

For the autumn picture (below), the whole paper was wetted first so that the paint ran in a soft, diffused manner. I sketched the scene with a sepia pen, leaving blank areas for the more delicate parts which I then painted in soft watercolours, using a rigger brush. The main colours I used were yellow ochre, light red, raw umber, violet, viridian green and cerulean blue. For autumn scenes, I like to use a misty blue background, which seems to make the autumnal shades more vibrant and alive. The greys

Figure 90 (opposite). *A profusion of wildflowers.*
Figure 91. *An allotment in autumn.*

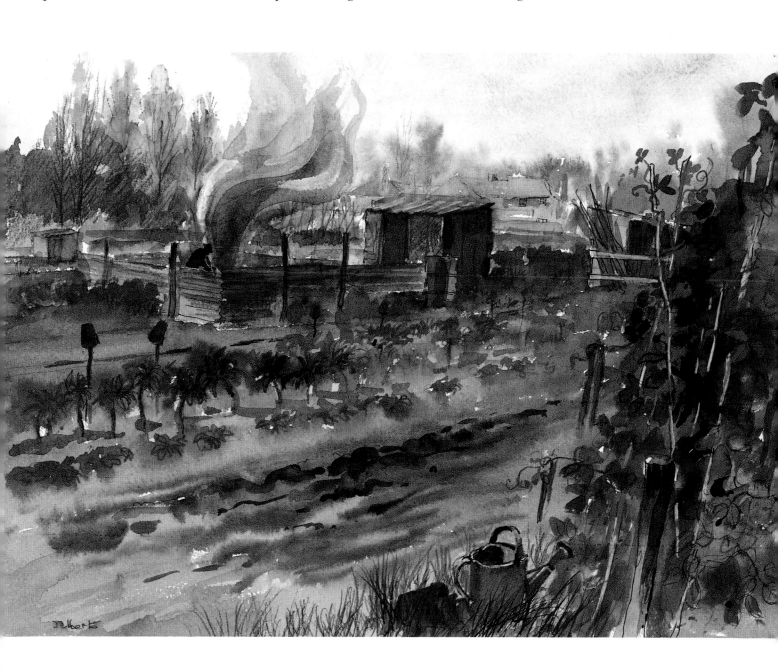

were a mixture of violet and yellow ochre, and cerulean blue and light red. The soil was violet, or raw umber fading into yellow ochre with a tinge of violet.

In the winter picture (below), much of the watercolour paper was left untouched, as in some of the snow areas. The sharp details, such as the wire, were painted in white gouache. Some of the fallen snow details were scratched out using a sharp knife, to give a dragged and uneven effect. I used raw umber, light red, Paynes grey and blue. The bare trees were painted in Vandyke brown, using my favourite rigger brush.

The random branches and grasses jutting from the duvet of snow were splashed in beforehand with an old toothbrush laden with masking fluid (glue could be an alternative), splattered over the required area and allowed to dry. I dropped some sea-salt into the darker snow wash while it was still very wet, to get that intriguing mottled look.

Figure 92. *The same scene is transformed in winter.*

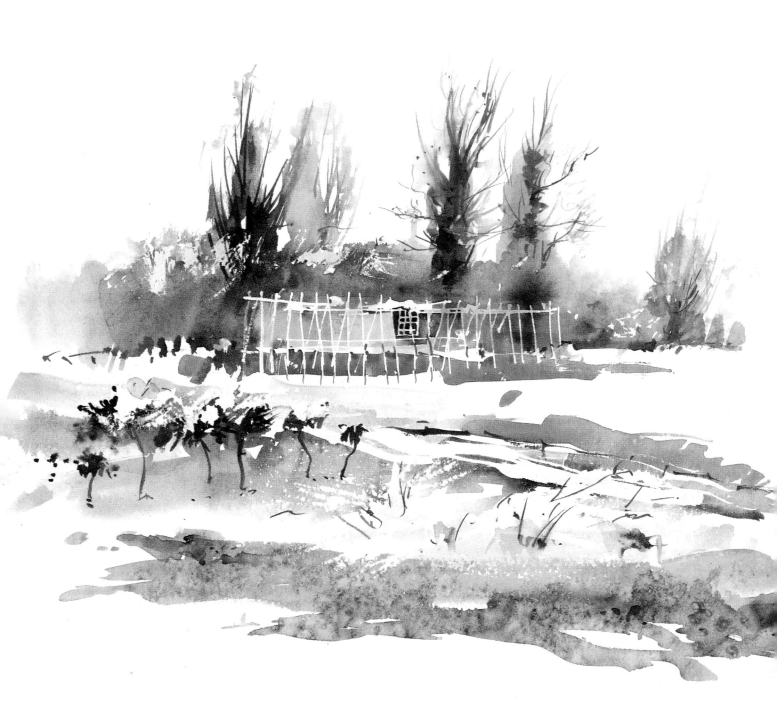

AMERICAN GARDENS

I am always intrigued by the fact that all gardens are so diverse and therefore unique. This is even more apparent when you look at gardens from different parts of the world. These three American gardens are based on Mexican, Spanish and Italian styles. Below is a garden in Santa Barbara, California. The exotic jumble of palms caught my eye, and I especially like the peephole effect seen through the Californian oak, framed by the impressive vine-clad Spanish-type house beyond. The distant violet hills set off the light red tiled roof; I continued the light red theme into the glowing sky, running this wash into a vivid cerulean blue.

Under the front steps, I placed three lines of masking fluid to highlight their sunlit tops, which contrasted beautifully with the grey-green watercolour of the crazy paving on the patio. The palms were treated with masking fluid and, after this had been gently rubbed off, I used cadmium yellow and a touch of olive green for the shaded areas. I sharpened up the two dramatic-domed doorways and darkened the whole of the peephole to emphasize the stark whiteness of the house.

In Figure 94 (page 116), I chose a beautiful enclosed, cloister-like garden for its sheer joy of tile decoration. It seemed to me like a time-capsule and could have been of any age. I drew the scene with great care, then wetted the 140 lb (300 gsm) watercolour paper before adding light red and a little violet and olive green to the floor, balcony and tree-shaded depths of the background. Whilst still damp, I ran in the foliage, using olive and Hooker's green. I dabbed in cadmium yellow to the lefthand top corner, to give a feeling of bright sunshine which bounced onto the tiles and potted foliage. The fountain water was white gouache and cerulean blue, and I added a little light red and olive for the windows in the shadows on the right. White gouache and yellow were quickly mixed and applied to the tops of the plants to add extra contrast to the deep shadows, remembering the saying 'the brighter the sunshine, the darker the shadows'.

Figure 93. *A garden in Santa Barbara.*

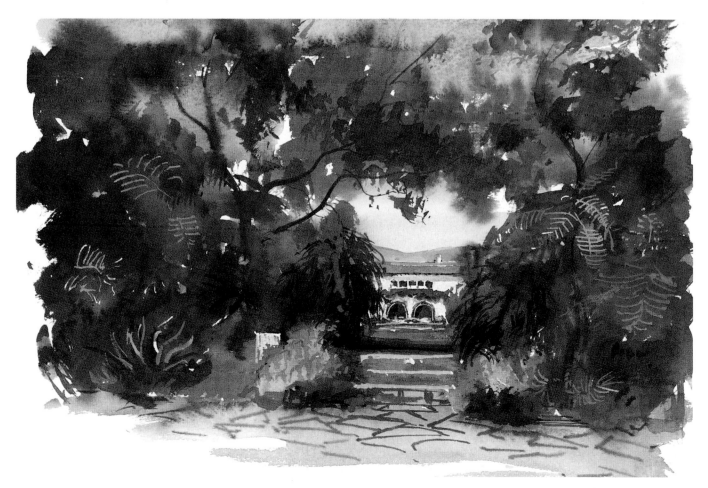

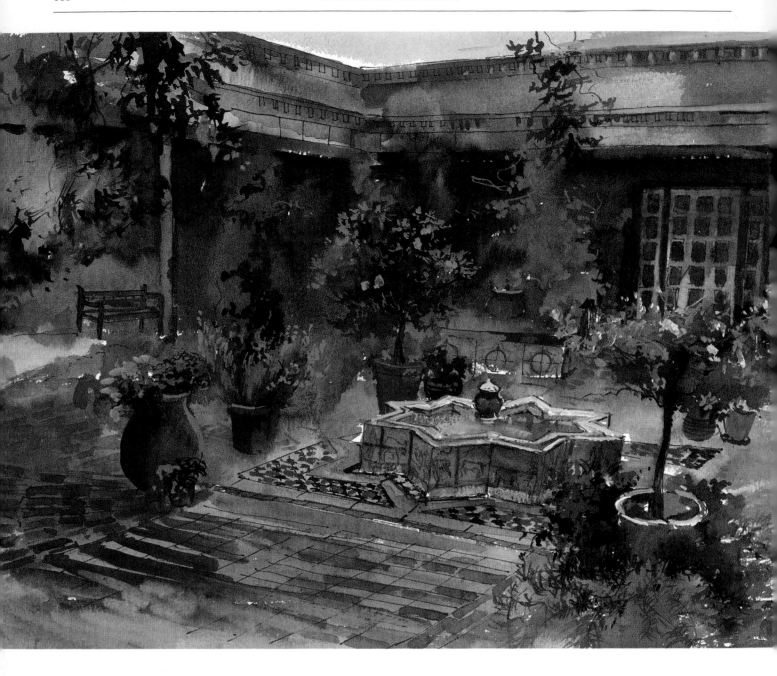

Figure 95 (opposite) shows the more formal and traditional garden at Blake House, Kensington, California, which belongs to the University of California at Berkeley. It has many exotic and Mediterranean-type plants and is known for its grotto, lined with blue tiles and flanked by this lovely staircase. I liked the natural stone effect, and the yellow ochre and violet mix contrasted with the gorgeous greens that flowed down its sides. I emphasized the markings and various shapes between the stones with very sharp aquarelle pencils in blue, violet and dark umber. Large dark conifers, painted in with violet and dark greens, holly ferns and Irish yews formed a thick mantle for the background. Some of the more delicate ferns and texturing were drawn again with my faithful pencils, using pinks, greens and ochres.

Figure 94 (above). *This peaceful garden has a timeless quality.*
Figure 95 (opposite). *A formal garden in Kensington, California.*

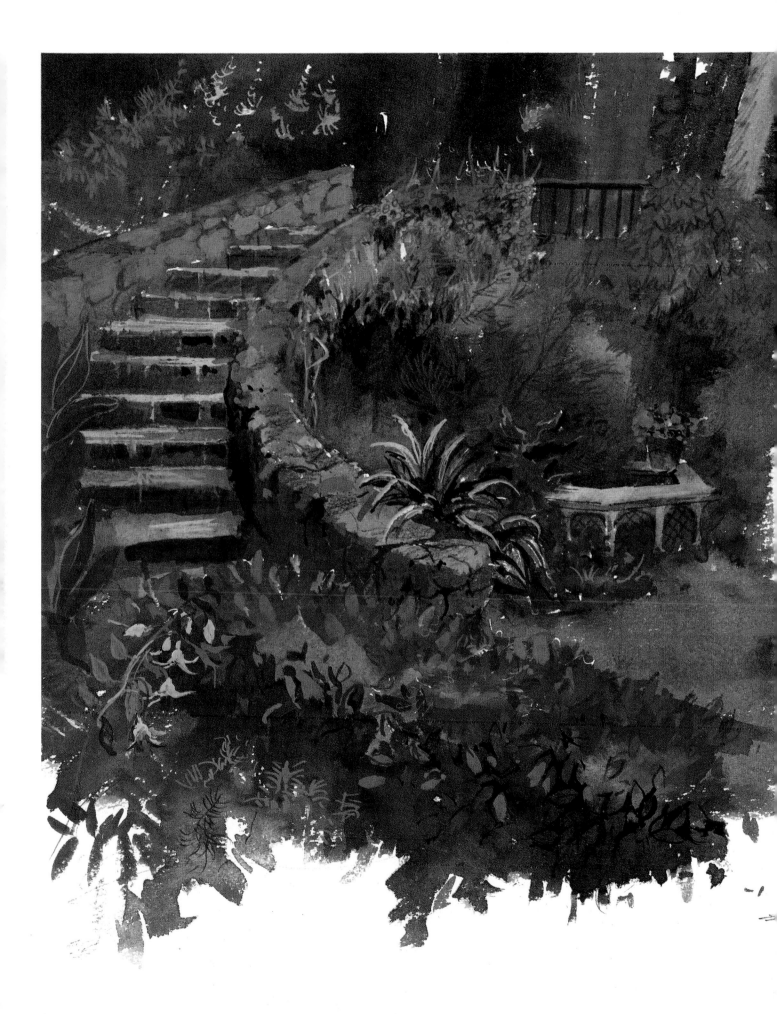

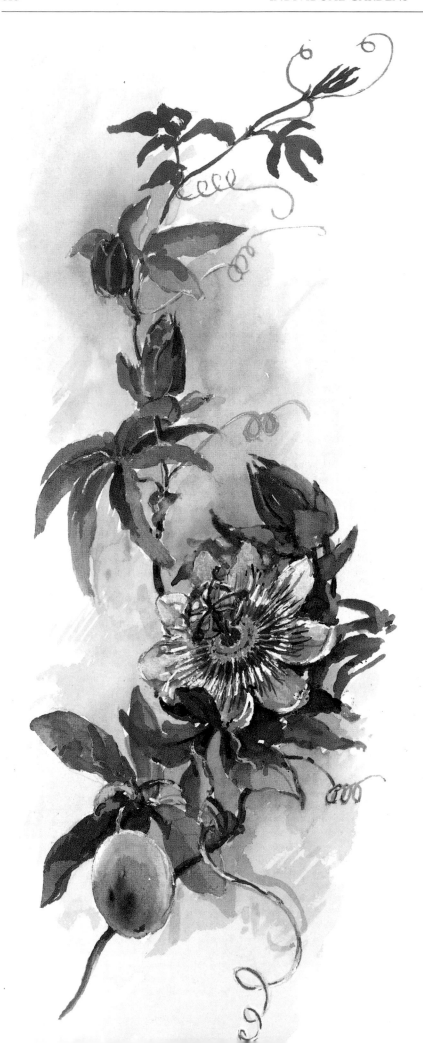

ELIZABETHAN PRIORY

I was commissioned to paint this Elizabethan priory in Titchfield, Hampshire. I had caught only glimpses of the mellow old building through the shrubs and trees of the drive, but as my car finally swung into the clearing in front of the house, I was thrilled. The lead-light windows winked in the sunshine and the brick chimneys stood tall, like soldiers guarding the garden below. I couldn't wait to start!

I started with a 'doodle' in inks, depicting the back door and small patio area (Figure 96a), using a black steel-nibbed drawing pen. I wetted some of the paper to get a diffused look and made several exploratory studies. Inks cannot be used by the faint-hearted, as they are usually permanent; concentration is the key word! I splattered some ink for the pebbled path, and dropped some large spots to depict undergrowth and random foliage. I tightened up the grasses and textures of surrounding climbing plants and buildings. Finally, I added some diluted inks for the softer washes.

I viewed the Priory from many angles and made rough sketches. My patron chose her favourite and, together with photographs, I would use all of these to help with my final painting. I photograph many features as well during my visits. I have used the windows, doors, patio urns, garden furniture and pots in previous chapters of this book, so my visit was very

Figure 97. *An isolated passion flower.*

productive. The painting of the passion flower (Figure 97) is a perfect example of the kind of 'extra' subject you always find when you are doing a commission. For all simple subjects, a background wash gives depth and interest, allowing the eye to rest content with the 'whole'.

The final painting (below) combines the use of violet and yellow ochre. Violet is used with light red in differing strengths for the roof and is also mixed with greens, particularly in the shadowed areas. Using

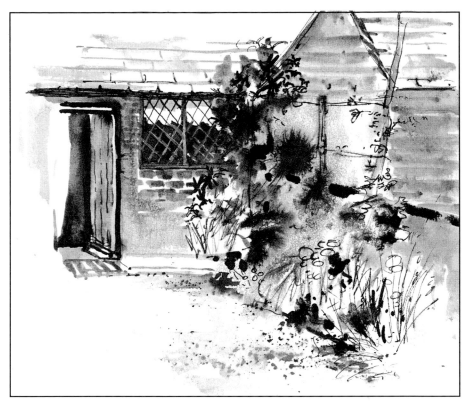

Figures 96a and 96. *A preliminary sketch (right) helped in creating the finished painting of this Elizabethan priory (below).*

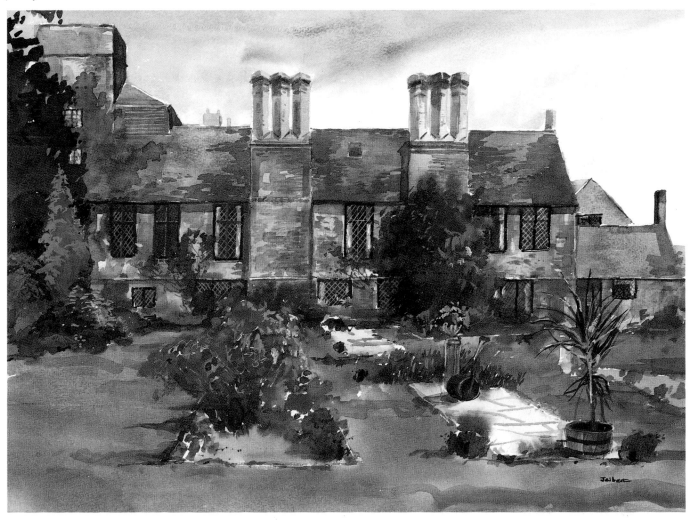

opposites from the colour wheel always adds vibrancy to a painting; try a green-red or orange-blue combination. The Impressionists used this technique to great effect.

I used a little masking fluid to convey the sunlit patches on the rose trees and spiky potted plant in the foreground. The distant conifers, painted in different cool and warm greens, are a foil to each other in shape and colour. I also liked the way the light windows within the shadows in the tower on the left contrasted with the dark windows in the rest of the building. During the Spanish Armada, a fire burned on top of this tower to warn people that the Spanish fleet was on its way!

WISLEY

The beautiful gardens of the Royal Horticultural Society at Wisley, not far from London, are a mecca for all lovers of gardens. The Society has been a source of inspiration and delight for over 80 years, giving advice on pests, plant identification and diseases, experimenting with plants in the trial area at Portsmouth Field and the glasshouses, running a one-year course at the School of Horticulture, and offering educational talks and practical demonstrations to the general public. The pleasure of learning in beautiful surroundings is the very essence of Wisley.

Figure 98 (below) is a glimpse from the Wild Garden towards the Alpine Meadow, with the azalea *Rhododendron amoeum* in the foreground. The paper was wetted first, using cerulean blue, cadmium red, cadmium yellow, Hooker's green and Vandyke brown to imply a misty background using the 'wet-into-wet' technique.

Figure 99 (right) shows one of the lush greenhouses, bulging with sumptuous plants and flowers. I was fascinated by the huge banana plant (Figure 100; far right) with its large, protective leaves harbouring the pale green fruit. I used sepia ink for a first impressionistic drawing, then olive green, yellow and light red watercolours for the greenery, highlighting the leaf veins and fruit in gouache paint (mixed with the original watercolour paint). While the paint was still wet, I dropped more ink into the background to give texture and interest.

The rather intimate setting for the greenhouse was discovered near one of the Model Gardens, created for people with special needs.

In Figure 101 (overleaf), I have tried to capture the Rock Garden, founded in 1911 when these were at the height of fashion. The ledges of rock and stone steps are covered with powderpuffs of colour and texture. Nestling mounds of foliage and tiny flowers, spiky iris and the meandering figures, relaxed in the sunshine, contrast with the dark conifers in the background. Most of the scene was painted in watercolours. Where the trees

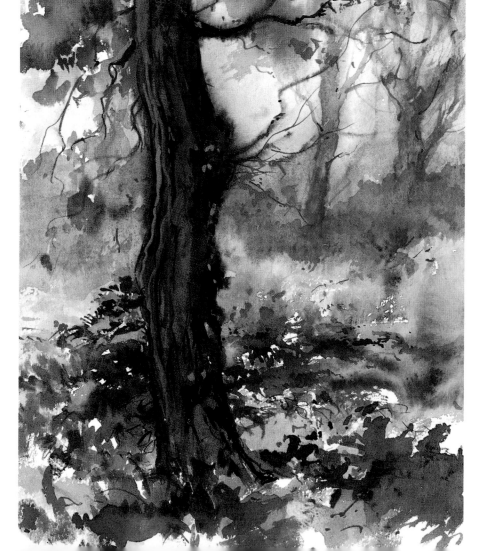

Figure 98. *View towards the Alpine Meadow at Wisley gardens.*

appeared too heavy, I painted in the sky colour on top of the foliage with a little gouache and blue. To add a little strength on the figures, I also used a little light gouache. As I painted the scene, I touched the same colour I used for the garden into the water's reflection, giving it a feeling of unity with the scene above. Lastly, I used a rigger brush to draw in some ripples from the main reflection, giving movement, and painted some extra lilypads into the sky reflection, then highlighted the lighter areas within the reflection for contrast.

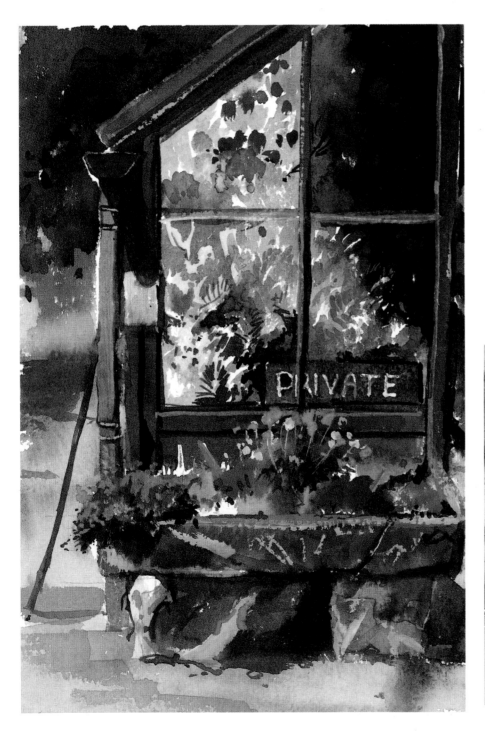

Figure 99 (left). *A greenhouse filled with plants and flowers.*
Figure 100 (below). *A banana plant painted in sepia ink, watercolour and gouache.*

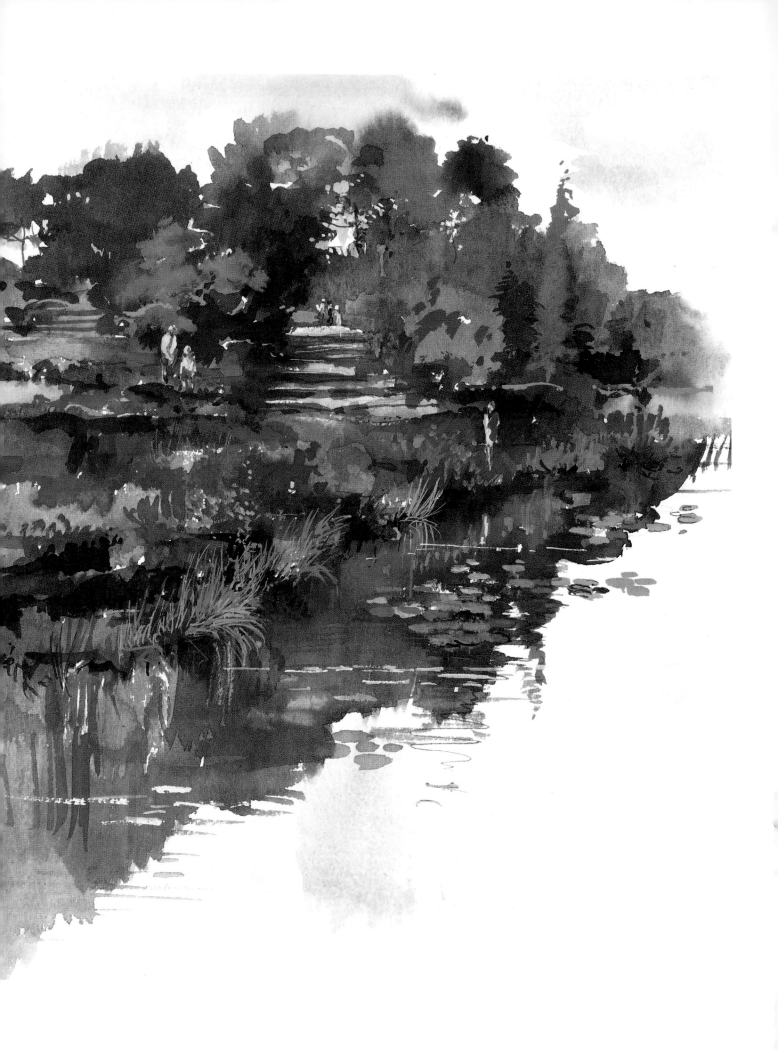

LANHYDROCK

The formality of Lanhydrock near Bodmin is a surprise in the county of Cornwall. It is a splendid stately house set in 450 acres of woodland, standing high above an area of sycamore and beech trees. The formal lawn in front of the house is punctuated by cone-shaped Irish yews, some very old.

I decided to paint the crenellated gatehouse, built in 1651 (below). This compact building was grey-green with blotches of yellow ochre, a mixture of cold and warm greys, some pinks and blues, with splashes of green foliage. The surrounding dark yews gave a good contrast to the lighter stonework of the walls and building, and I put in some figures to give perspective and scale. I used watercolours in yellow ochre, a grey made with burnt sienna and cobalt blue, olive green and Paynes grey. The details were drawn with care, using a sepia steel-nibbed pen. The highlights are in white gouache mixed with yellow ochre, applied with a rigger brush, size 1.

Figure 101 (opposite). *The Rock Garden at Wisley.*
Figure 102 (below). *The imposing gatehouse at Lanhydrock in Cornwall.*

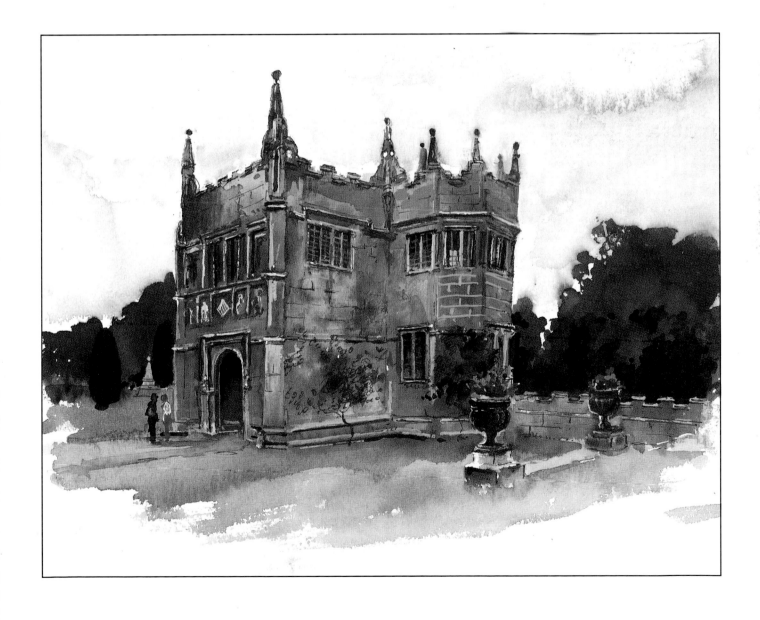

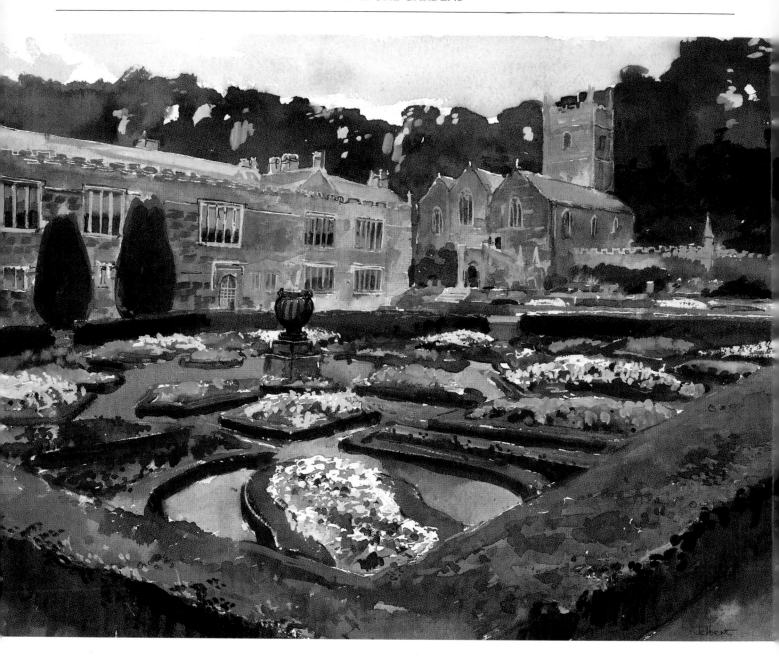

The picture above shows the parterre to the north of the house. This is a creation of low box hedges harbouring colourful beds of flowers. The complicated designs were quite a challenge, in perspective, colour and tone. The picture needed concentration and effort to gather all the correct information needed to portray the detail of garden, house and church.

I began by using masking fluid for the light details, such as the rooftops, chimneys, windows, steps and dark urn, and let it dry. I then washed over a warm mushroom-pink gouache paint (ready-mixed and a very useful tube to have in your paintbox), and while it was still wet added a little yellow ochre to the walls. At the same time, I washed in the distant trees in blue, olive green and yellow ochre, gently fading one colour into the other. The flower colours, of vermilion, and yellow and white gouaches, were varied in tone and strength by the addition of water, varying from bright to very pale pink and from yellow to white. The texture of the box hedging was made by dotting and splattering darker paint over a lighter one.

Figure 103 (above). *The formal parterre at Lanhydrock.*
Figure 104. *The bridge in Monet's water garden at Giverny, made famous by his own rendition.*

GIVERNY

Monet's house and gardens at Giverny realized his dream of heaven on earth. He settled in this charming village in 1883, and created an oasis of beauty and tranquillity with an endless source of subjects to paint. His main aim was to portray flowers in the subtle effects of transient light during the changing seasons, weather and fleeting moments of the day.

The delicate white wisteria clambering over the turquoise metal bridge in Monet's Japanese-influenced water garden held me spellbound (right). Its blossoms and light streamers cover the bridge. The scene was quickly drawn with green aquarelle pencil, then masking fluid was applied to the white wisteria and the iris on the right. The whole drawing was then washed over and different greens painted into the willow at the back, and over the water reflection and the banks. While the paint was still wet, dark green (olive and violet) was dropped in to add depth. Care was taken not to cover the lighter lilypads. When it was partly dry, I painted in the remainder of the tree reflection, in a downwards direction. Vermilion was then added to the flowers on the riverside and dotted into the water. I removed the masking fluid, and drew in the main details of the bridge railings, the white wisteria, the iris and the reflections, using a sepia steel-tipped pen.

Monet attempted to fill his garden with a wide variety of flowers to span the seasons and supply continuous colour. Cohesive harmony of colour created the perfect setting for his

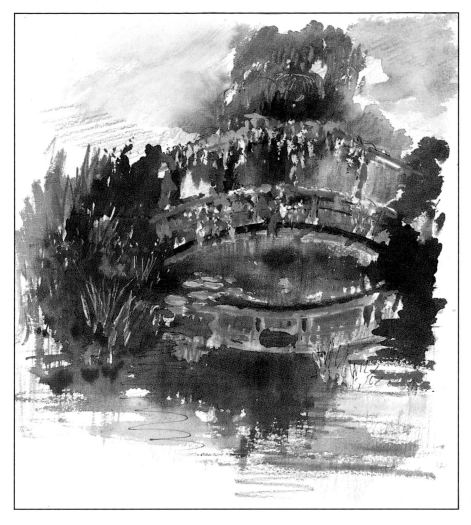

lovely green-shuttered, pink-walled house.

I used several aquarelle pencils in the drawing of the house, having already applied a very light wash of grey for the roof and green underwash for the foliage and trees (Figure 105, overleaf). The foreground irises were drawn in carefully with green and yellow pencils, then I painted many of the leaves, iris heads and the spaces between the plants, using a rigger brush and a size 2 ox-hair round-headed brush. For this I used violet, yellow, alizarin crimson and orange watercolours, adding pencil work in greens and violet. The texture of the surrounding trees reaching skywards on either side

seemed to accentuate the soft smoothness of the pink farmhouse, and the green shutters echoed the fresh foliage colour in the foreground.

Finally, I *had* to paint a waterlily (Figure 106, overleaf)! Aquarelle pencils were again used to mark out the position of the flowers, amidst the lilypads in the foreground and receding to the distance. I used a dark red pencil that ran when I painted a pale wash of pink into the flower shapes. Whilst still wet, I spotted in cadmium yellow so that it ran intentionally into the surrounding pinks. White gouache mixed with red watercolour was added where a bolder pink was needed. The leaves were veined in green,

pink and blue pencils, and in the underpainting I used yellow and blue to create shade and sunlight. Finally I drew in the details and outlines in red and violet.

Today Giverny is a living museum — one of the most famous gardens ever to inspire a painting!

Figure 105. *Irises fill the foreground in this painting of Monet's house.*
Figure 106. *Waterlilies at Giverny.*

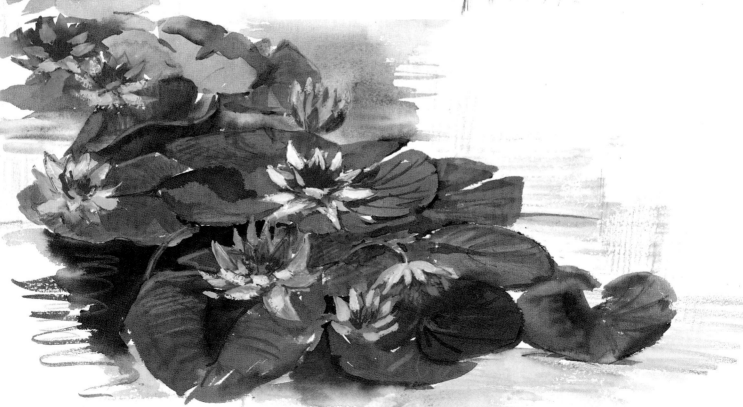

CONCLUSION

As I hope you have now discovered, garden painting offers endless scope and inspiration for the artist, whatever your style, interest or stage of development.

Sweeping landscaped gardens or still-life corners of flowerpots and tools create different challenges, and variety within a familiar theme. If you are lucky enough to live by the sea, water and boats can be an added backcloth to your garden scenes. In any garden, figures, wildlife, buildings and botanical studies of flowers and leaves provide inspiration at different times of year.

As I gaze through the window on a cold March morning, my eye is immediately attracted by a branch of beautiful catkins hanging motionless in the air; the sharp focus of colour and form contrasts perfectly with the frosty impression of the garden beyond, providing me with yet another subject to celebrate the coming of spring.

Art is a combination of the practical and the intellectual and, like music, success cannot be achieved with theory alone. The mastering of a medium, any medium, is the simple part; and the development of style and vision is a lifetime's challenge, achieved by enthusiasm and effort.

Looking, seeing, really seeing, is the first step on the road to successful painting — practice is the next. I wish you a wonderful journey!

INDEX